NANTUCKET

Cary Hazlegrove

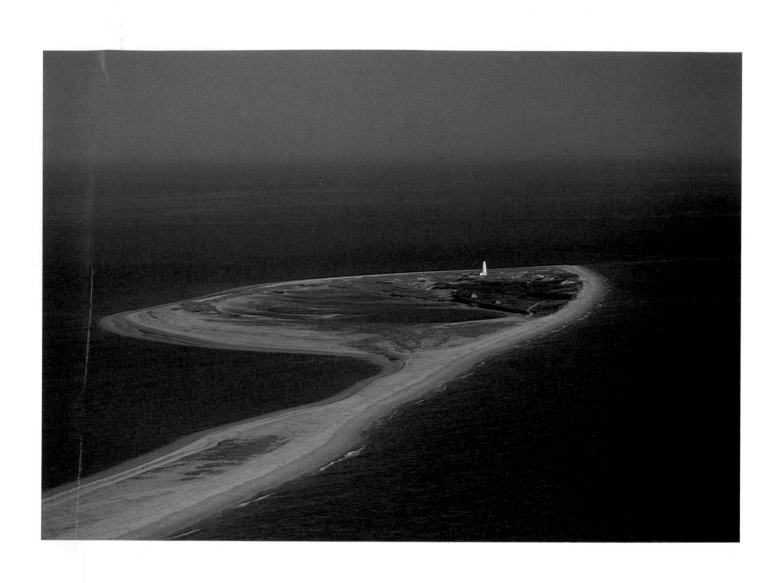

NANTUCKET

Seasons on the Island

Cary Hazlegrove

Introduction by David Halberstam

CHRONICLE BOOKS
SAN FRANCISCO

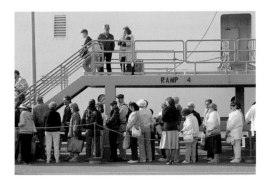

Printed in China.

Book and cover design: Merrick Hamilton

Library of Congress Cataloging-in-Publication Data:
Hazlegrove, Cary.
 Nantucket : seasons on the island / by Cary Hazlegrove.
 p. cm.
 ISBN 0-8118-0724-X
 1. Nantucket Island (Mass.)—Pictorial works. I. Title.
F72.N2H29 1995
974.4'97—dc20 94-11554
 CIP

Distributed in Canada by Raincoast Books,
8680 Cambie Street, Vancouver, B.C. V6P 6M9

10 9 8 7 6 5 4

Chronicle Books
85 Second Street
San Francisco, CA 94105

A C K N O W L E D G M E N T S

To my parents, Wilbur and Lucy, for raising their children as artists
and for their love, encouragement, and inspiring ways.

To my brother, Billy, for his artistic support in the proposal stage
of this project, and to my sisters, Page and Sarah, always a phone
call away.

To Sarah Chase for getting me started in the world of books.

To Ann Schmidt, Kate Martin, and Jordi Cabre, my tried-and-true
assistants.

And to the following people who have been an integral part
of my life on Nantucket: Mimi Beman, Noël Berry, Rick Blair,
Bruce Courson, Laura Evans, Bonnie Fitzgibbon, Donnie Johnston,
Gene Mahon, Lindsley Matthews, Robert McKee, Libby Oldham,
Terry Pommett, Christine Sanford, Amy Sutherland-Thompson,
and Sally West.

And to Charlotte Stone for believing in this book.

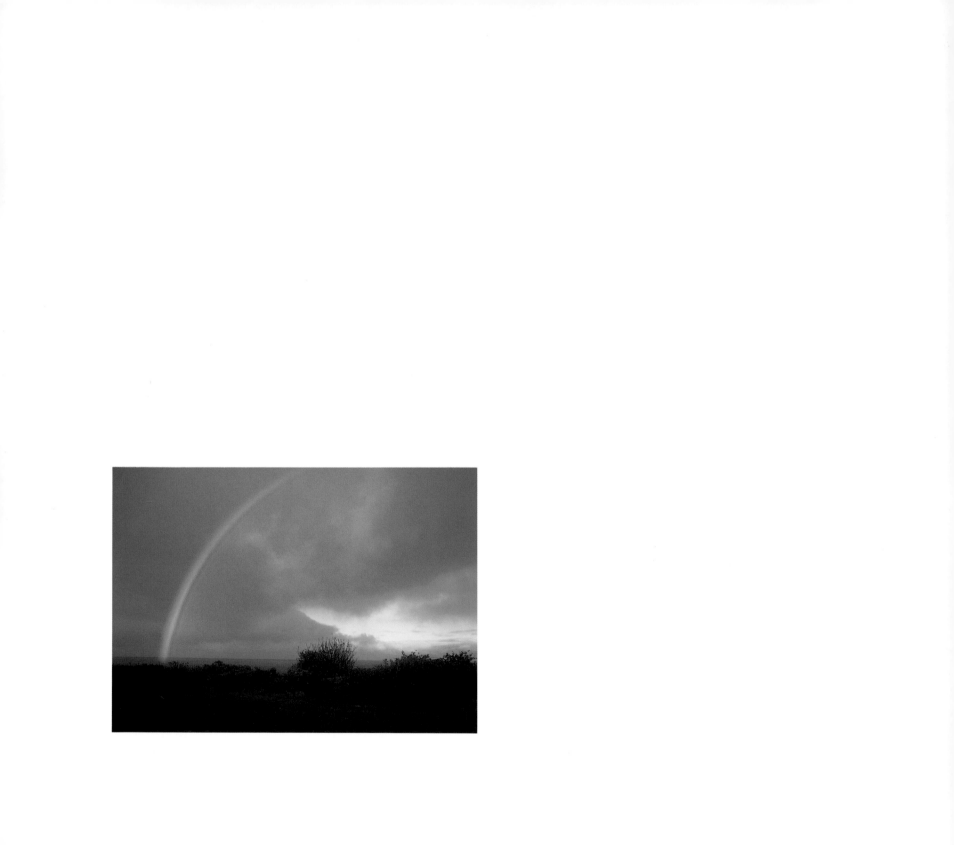

To Nantucket,

for standing still while I took your picture

&

to my husband, Andy,

for letting me live in two places at the same time.

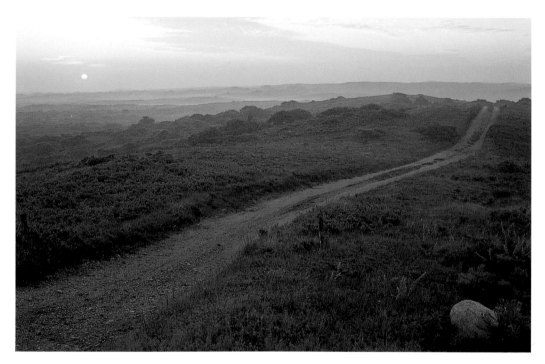

Polpis

Nantucket constantly pulls at my heart, and everyone I know who lives or visits here is touched by this miniature world of open space and devoted people. Her boundaries simultaneously challenge our lives and add comfort to our souls. I have devoted the past seventeen years to recording and preserving the past and present life of this island, my home. I hope that this book will remind you of times spent on Nantucket or at least encourage you to visit.

From my earliest days here, I realized that Nantucket people have an intimate relationship to the land, water, weather, and seasons. The physical beauty draws people out, and being outdoors on Nantucket is an important part of life. This was a significant discovery for me because it became the foundation of my work. I learned about weather and keeping one eye on the sky. Nantucket's landscape is open and uncluttered, which taught me how to see. The light is clear, clean, and soft, conditions that every photographer seeks. I began early on to take pictures of my island life, of friends and neighbors, of my backyard, and of the many small details that make Nantucket what it is.

Nantucket's time is marked by seasonal changes, and each season has distinct characteristics. Spring arrives a week before summer and

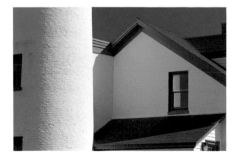

Coast Guard Station

summer lasts only two and a half months. Fall is short-lived and winter lasts forever. To fight off loneliness in the long winter months, I photographed. Picture taking is a very private and insular profession, and I found solace in dragging out my cameras. So much of the character of Nantucket is the gray, barren, isolated winter landscape where small hints of color are startling. I have always felt safe photographing on Nantucket, and I think this trust in my environment has been an important part of my work. There are few places left in the world where you feel comfortable photographing daybreak in your nightgown.

For me, Nantucket has been an easy and forgiving place to live. Having such a defined space to work has simplified my life, but finding new subject matter, year after year, has made it challenging. We have all watched many changes take place over the years, and looking back at my early work I am grateful that I was able to collect images of Nantucket that no longer exist. Buildings are torn down, open space is steadily decreasing, the shoreline is shifting, and old weathered houses are repainted or reshingled. Such changes are inevitable, but Nantucket has weathered them well.

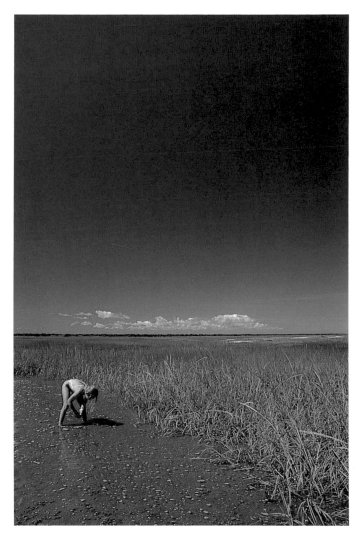

Coskata Pond

Cranberry bogs, Polpis

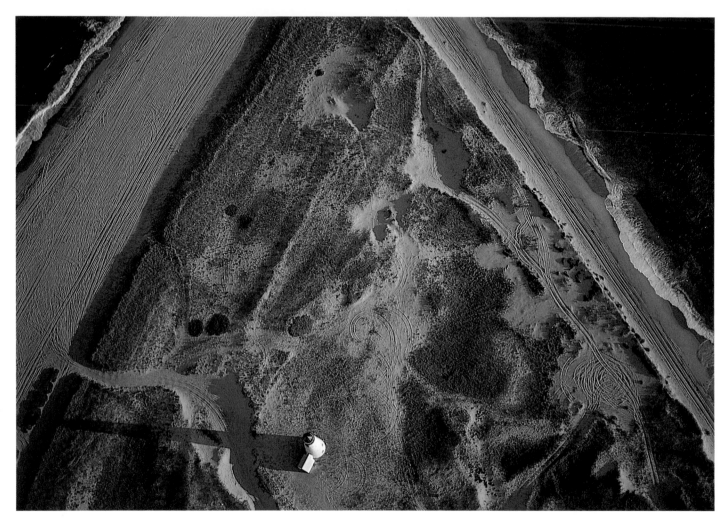

Great Point

Cary Hazlegrove first came to Nantucket in the spring of 1978

when she was twenty-one. She had just graduated from Hollins College

where she had spent a wonderful four years doing pretty much what

she wanted and very little of what she did not want, and which as

far as she could tell prepared her to do absolutely nothing in what

was still referred to as the real world. If anything, she thought of

herself as even more of a dilettante than most of her peers, taking

only the courses she wanted, mostly in art, and there seemed to be

no practical application possible for the education. Graduation had

come, and with it no promise or hint of career or job; she was just

another happy, aimless, young educated American with no discernible

future. She had absolutely no idea of what she was going to do

next. A friend of hers had worked on an island called Nantucket

the previous summer, and he had suggested that she go there,

meet some friends of his, and enjoy herself for a while; perhaps

she could waitress at a restaurant before she succumbed to the

pressures of the real world.

In time, on a freezing spring day, she arrived in Nantucket. She

had one name, that of Gene Mahon, a man who ran something called

the Camera Shop. That led to her first job, as a salesperson there, and

eventually to a benefactor who encouraged her to be the photographer she thought she could be, which eventually led to a career as one of the most talented photographers ever to work on Nantucket. Almost immediately she began to think of taking pictures of Nantucket, and in time it became both her vocation and, even better, her love.

Though she had never been north of New York City before, and though it was a bitter windy day when she arrived, she felt drawn to the island from the start, as if this was always the place she was destined for, as if this was her special place. This was where she wanted to live, she knew. It was the simplicity of the island that caught her: it seemed uncluttered and authentic, a place where form followed function, and where the simpler that things were, by and large, the more beautiful they tended to be. It was as if she had arrived to find a great personal moment of truth. In front of her, she felt for the first time, was the very purpose of her life: this was where she wanted to live, and this, taking photographs, recording the endless moods and the varying faces of the island, was where she wanted to be.

She had always liked taking photographs. The Hazlegroves of Roanoke, Virginia, were artistic people—her mother an artist, her father a corporate lawyer, a skilled woodcarver, and a singer. They

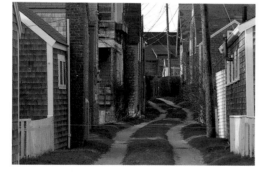

Front Street, Siasconset

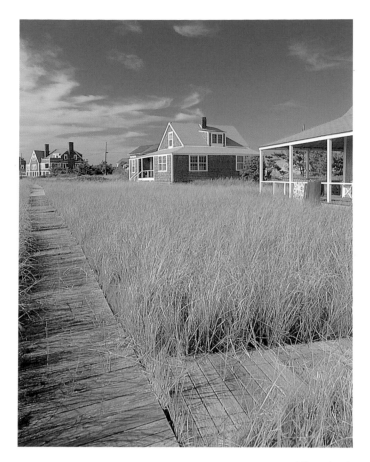

Wauwinet

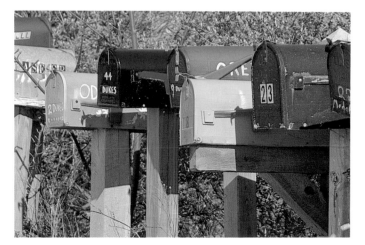

Dukes Road

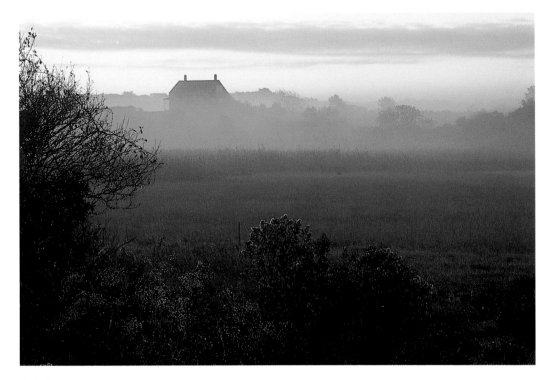

Polpis

had given her a good Japanese camera when she was fifteen and encouraged her to do with her life what seemed to interest her. They were not people who seemed to think that allegedly serious things like business and the law were more valuable than more frivolous things like art and taking pictures, and she had grown up with few rules about what was serious in life and what was not. No one in her family had protested when she took what were demonstrably far too many art courses of demonstrably little practical value at Hollins. Now caught up in photography, she was stunned as she looked back on her college career: she had not, as she had long supposed, been a dilettante after all. If anything, she had turned out to be the most practical of young women. She had used Hollins as a trade school, and she had gone there to do only one thing, and that was to educate her eye how to see and how to frame a picture. At first she photographed Nantucket at a somewhat leisurely pace. And then gradually she became more serious.

Soon after her arrival she and a group of photographers mounted a slide show about the island for the benefit of friends, and then in 1980 she started her own production company. Miraculously, people came and praised her work: word of mouth on her show spread, and today some 5,000 people a year attend her slide shows. The people at Hollins, she says, would have been surprised by what a professional

she has turned into. She trained to be an artist but had ended up something of a workaholic, shooting the island in earnest, working all the time, in all seasons, sensing the special beauty of the island, the beauty when it is bleak and the gentler beauty when it is not, trying to catch the island as it changes with the seasons, and sensing one definition of a place when it stands cloaked in the fog and a very different and separate definition of beauty moments later when the fog lifts.

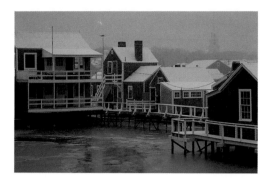

Old North Wharf

We share a love of the island. The Nantucket that I have come to love over more than twenty-five years is an ever-changing one. I like it in the height of the season, although I try to keep away from the crowds, and I like it in winter when it is bleak, and I like it best of all in the fall. Once my wife and I, already house owners in town, looked at a piece of land in the fall and were overwhelmed by the softness of the colors, the browns and grays and purples and crimsons and the final splash of green, and we proceeded to buy, only to find when we returned in the summer that the colors were too rich, that it was too green, and that we did not like it as much in summer as in the fall. I find the same appreciation for the island's different seasons and different moods in Cary's photographs. Some are full of color, and the blues and greens, the richness of the flowers, can only be summer, a time when there are often too many people on

the island. Some, by contrast, have the softness and loneliness and,
indeed, even the solace of the off-season, of fall and winter, when
bleak becomes beautiful.

Seventeen years of single-minded pursuit of so special a dream
has not been without its rewards, both interior and exterior. She has
the largest library of images of Nantucket on record, some 80,000
slides. It has become a world of her own, and in time she has created
her own record of the island in images that in the end are as real
to me as the island itself. What we have here is a remarkable
cumulative portrait of the island and its people, in season and out
of season. What moves me most when I look at these pictures is
that they represent not merely the physical face of an island I
know and love but that she has captured something even more
rare and elusive, the very soul of that island.

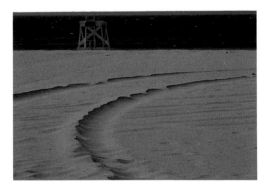

Cliffside

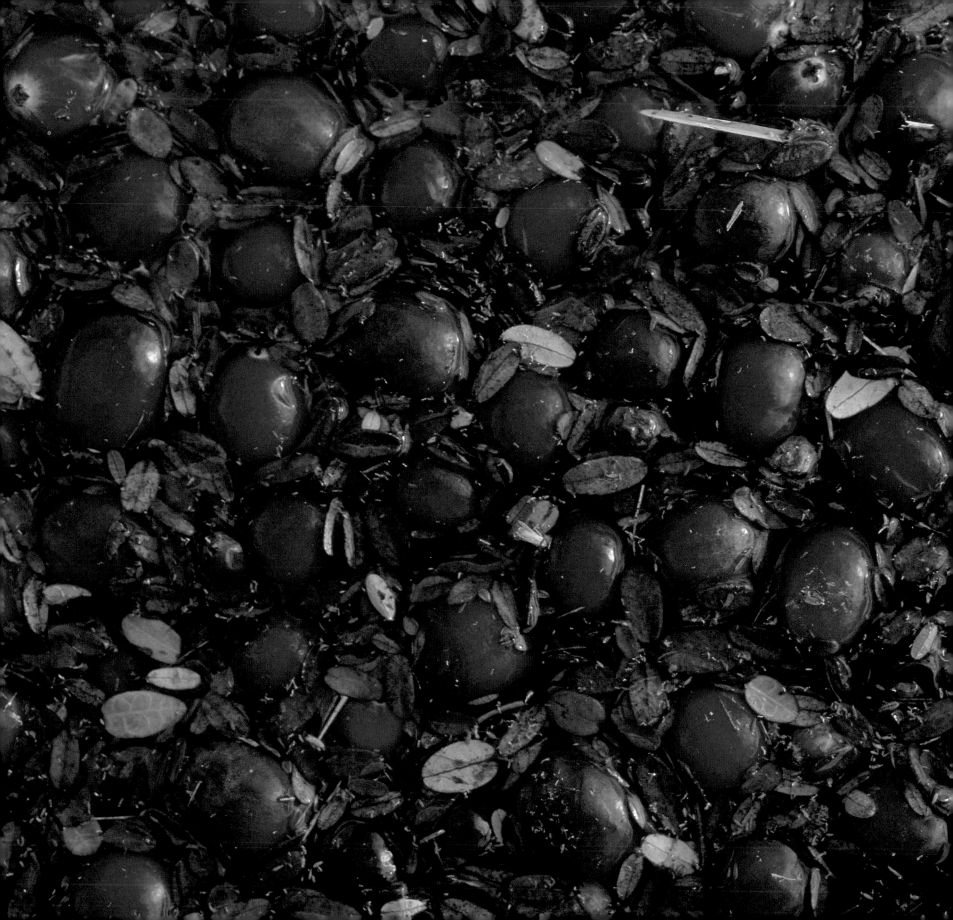

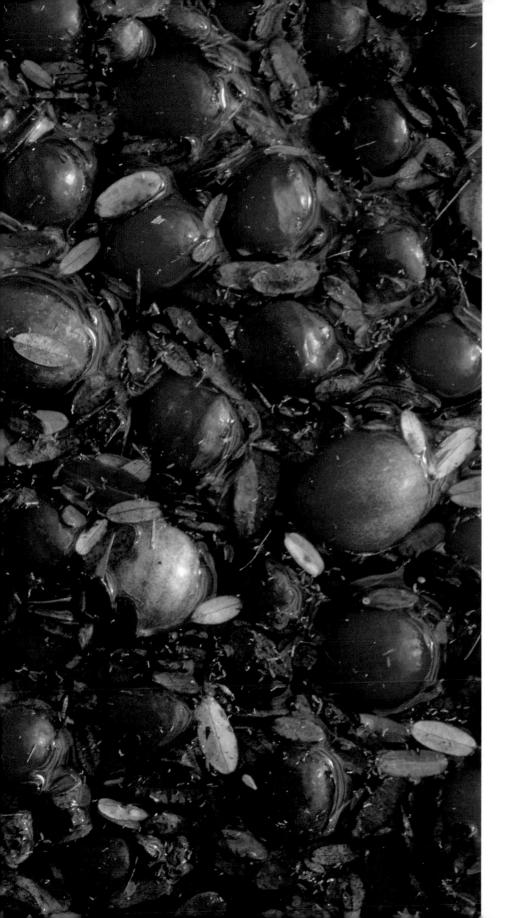

FALL

To drive around and have your eyes

and your soul filled with vista after vista

of moors and fog and shoreline

and pristine houses and flowers . . .

the beauty, the natural beauty

is overwhelming at times;

it's almost heartbreaking.

MARY BETH SPLAINE
Counselor

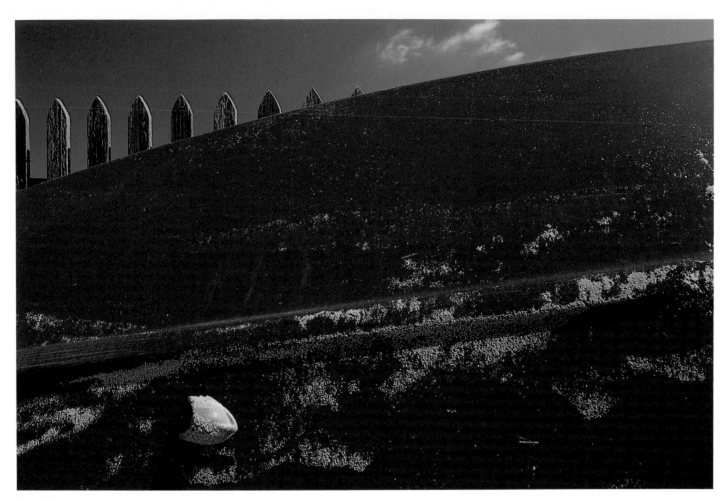

Sunfish, Hulbert Avenue

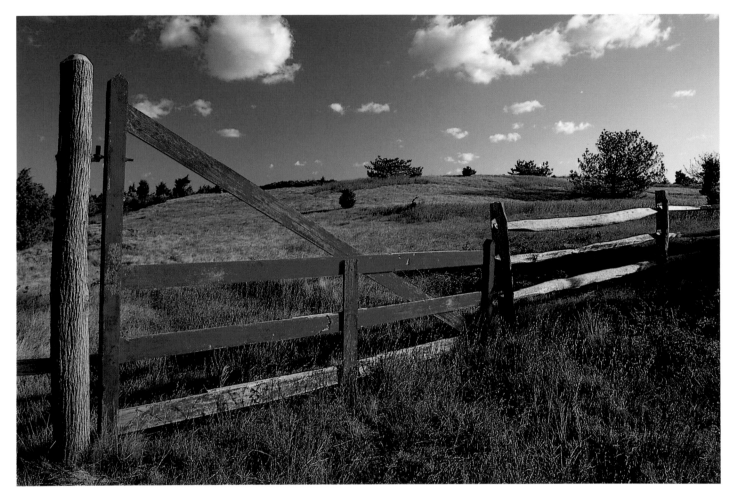

Polpis

Marine Home Center

I think the thing I like most about Nantucket is

the silence. It's enriching to the spirit of man

to be in a place like this.

LIBBY OLDHAM
Retired Director,
Chamber of Commerce

Siasconset Golf Course

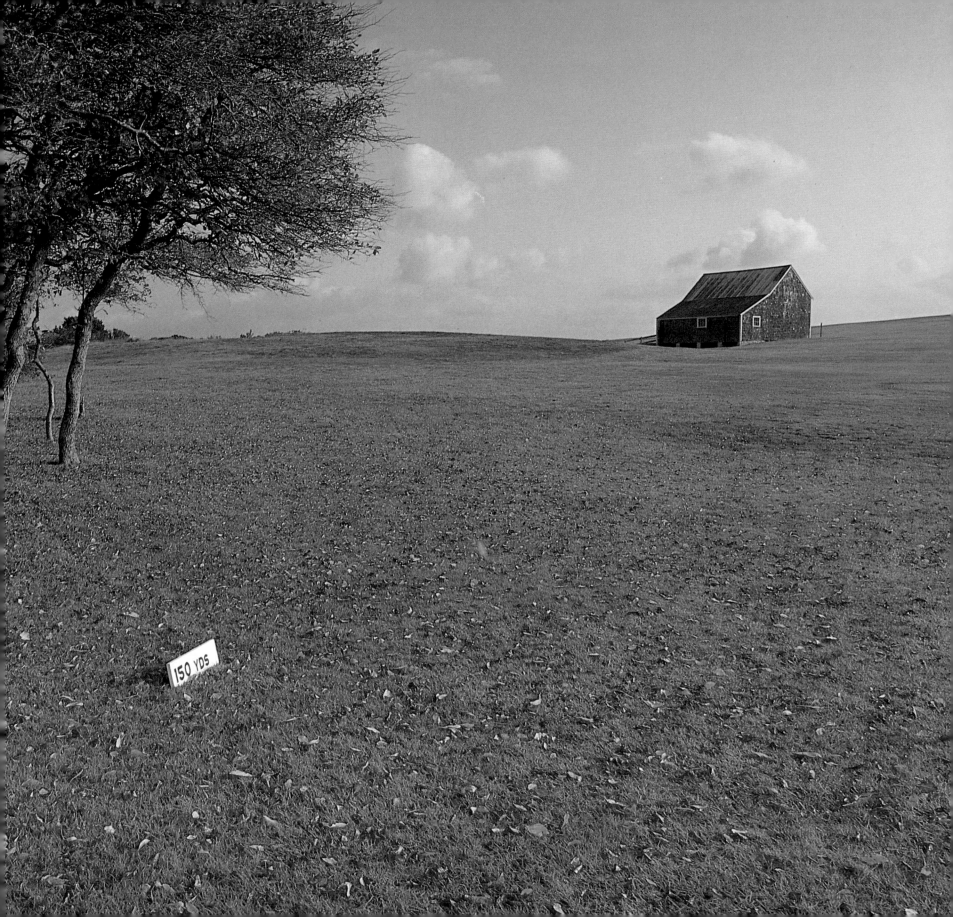

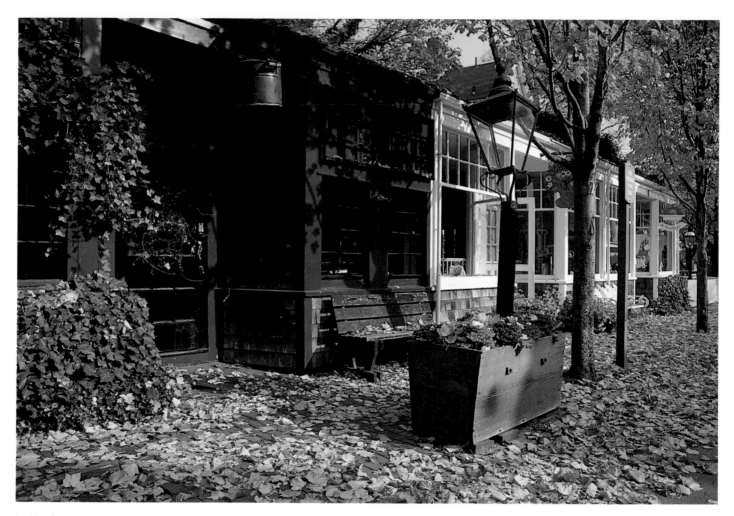

India Street

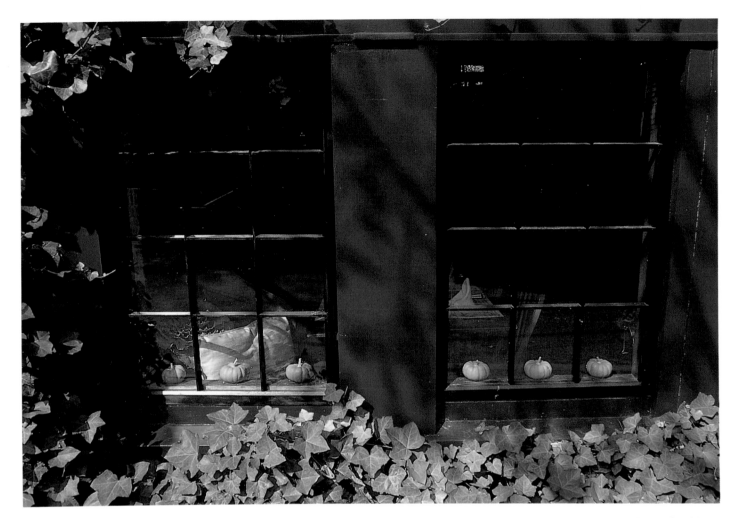

Company of the Cauldron

Main Street

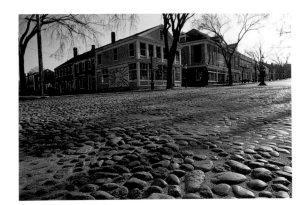

Main Street

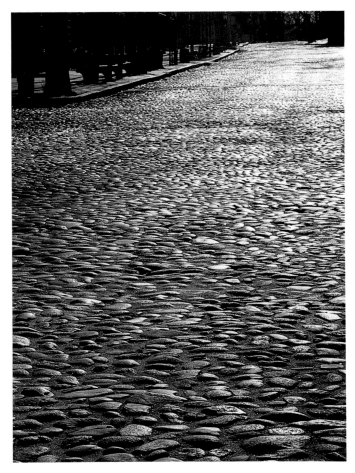

Main Street

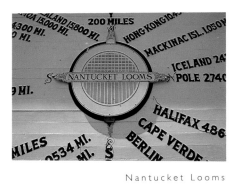

Nantucket Looms

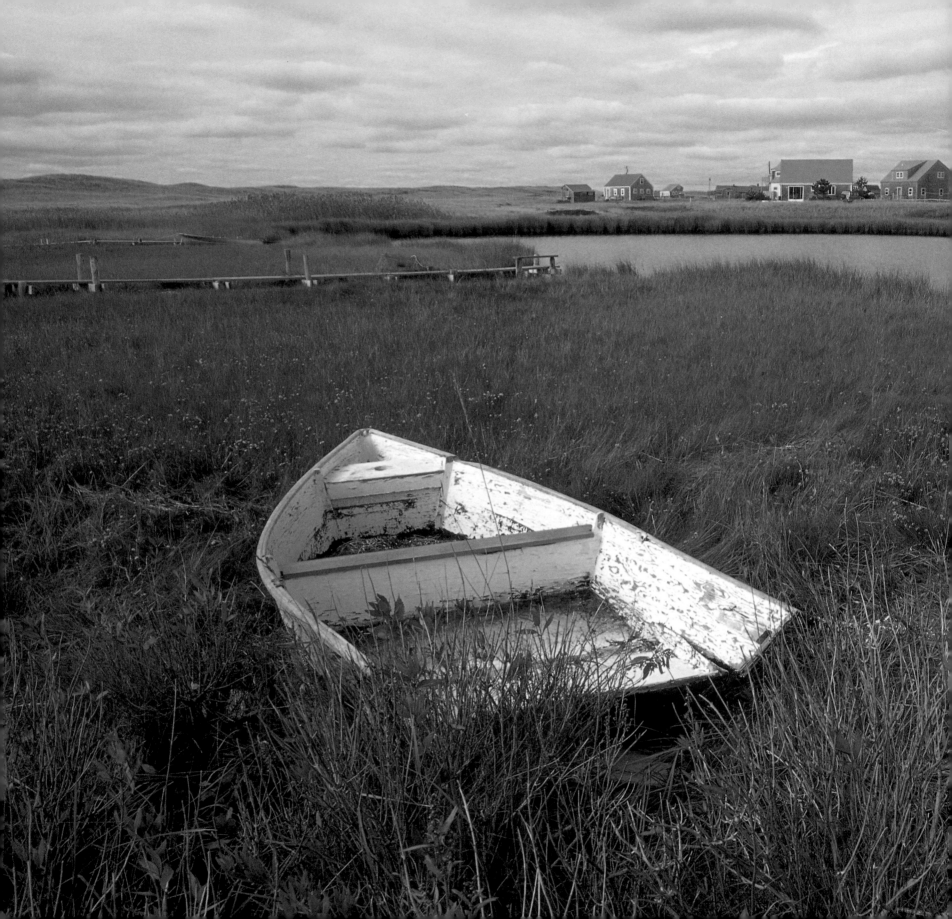

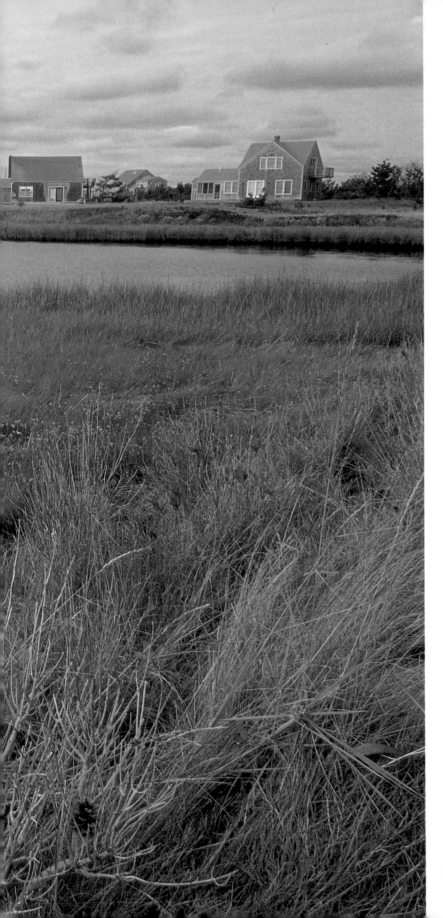

Madaket

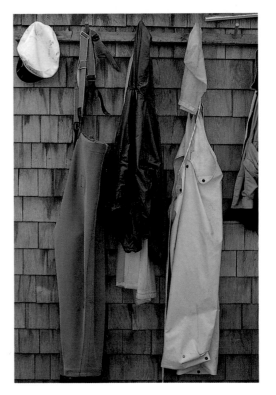

Little Toad, Polpis

Nantucket is a refuge from the rest of the world.

BOB REED
Bar Owner

11

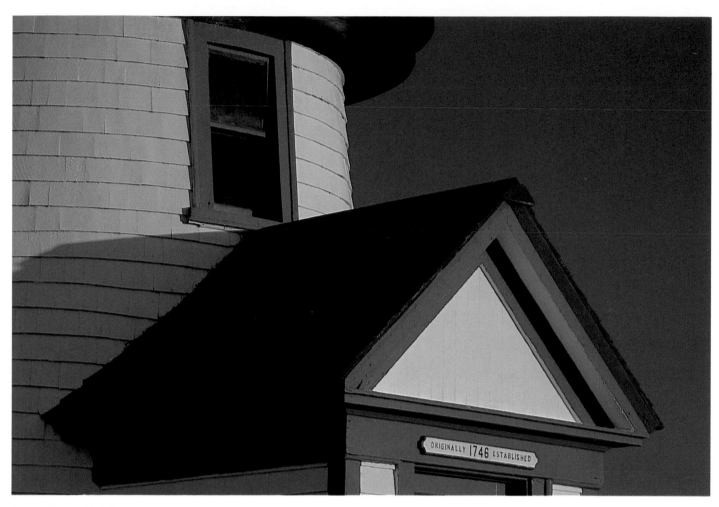

ORIGINALLY 1746 ESTABLISHED

Brant Point Lighthouse

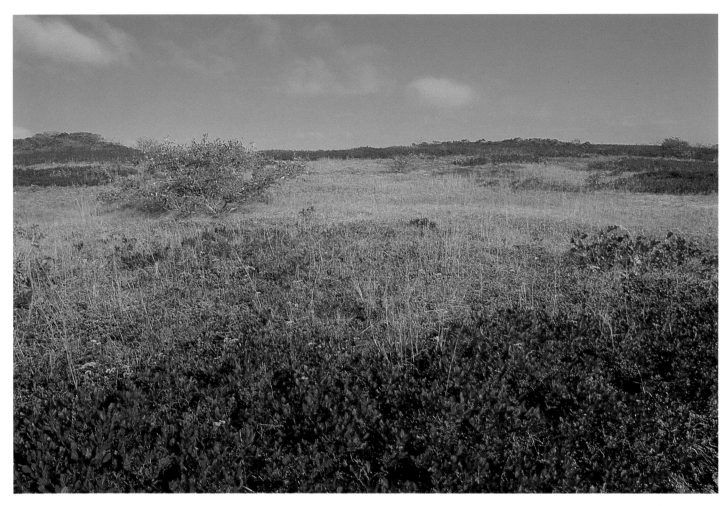

The Moors

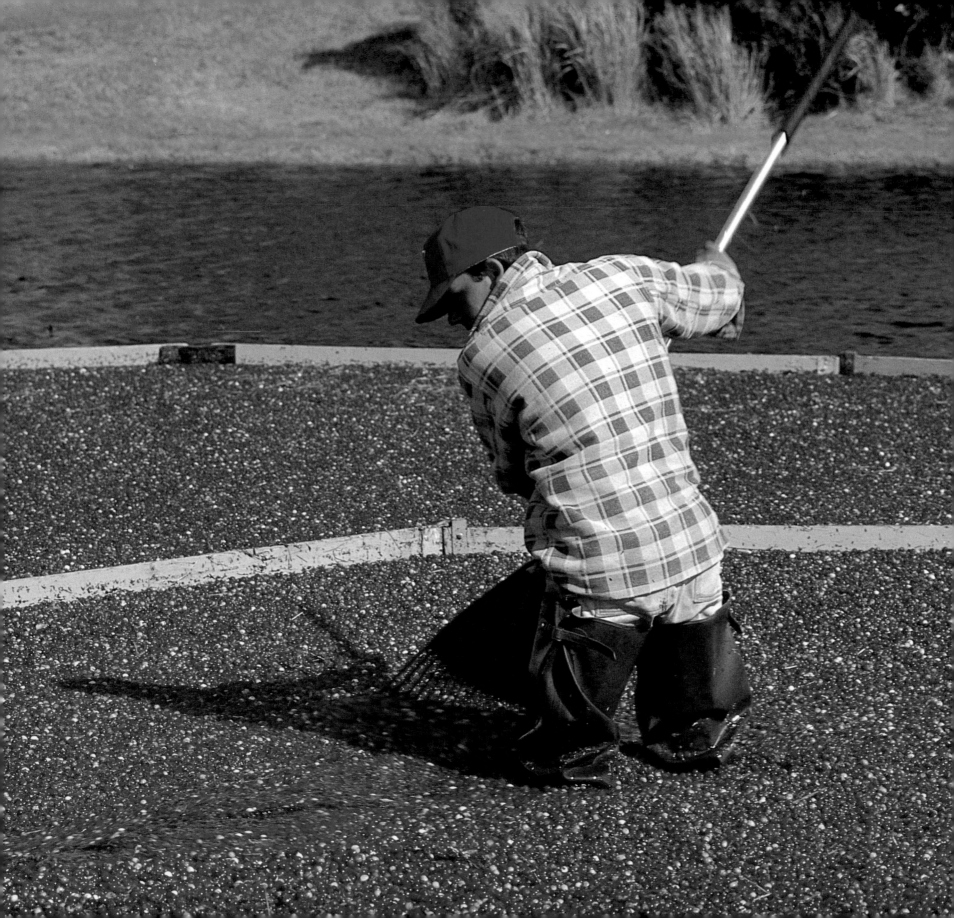

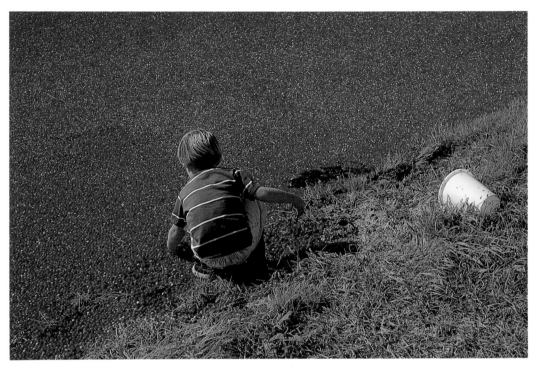

Windswept bog, Polpis

Cranberry bogs, Polpis

15

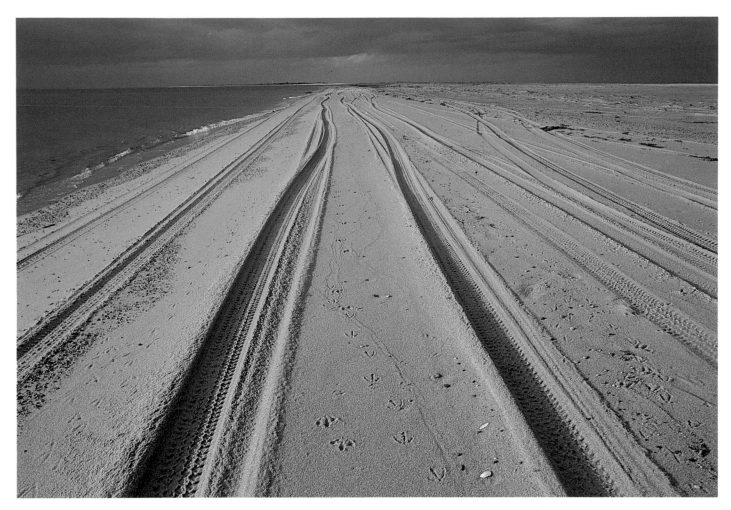

The Galls

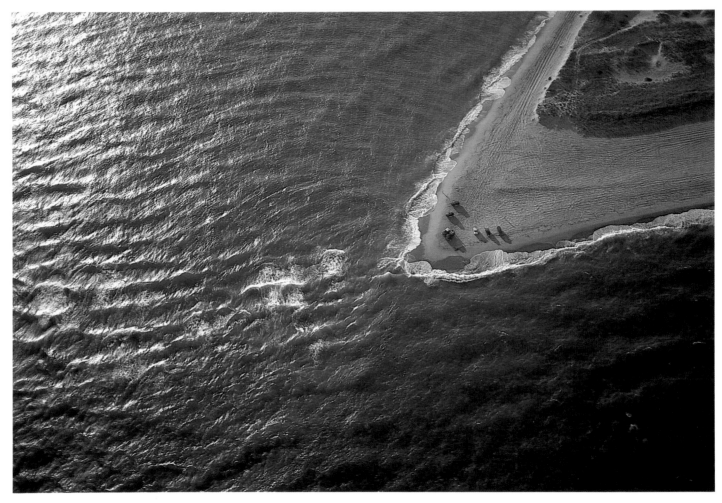

It's a mystical spot, that spit of sand that goes into nothing.

GEORGE MURPHY
Artist

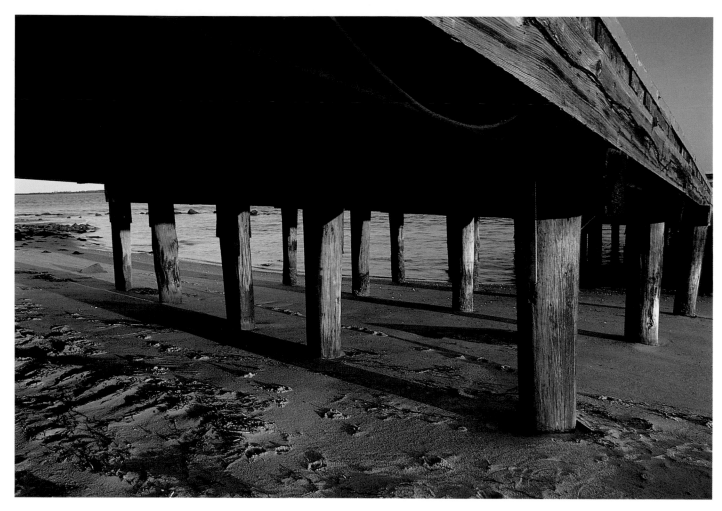

Old Coast Guard ramp

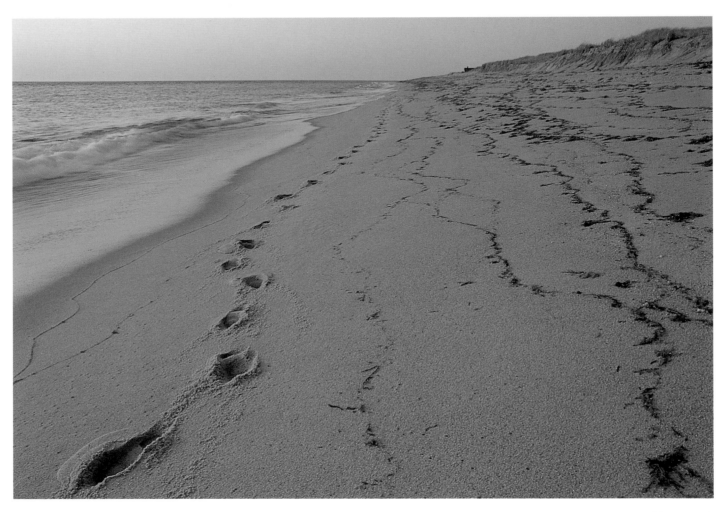

Siasconset

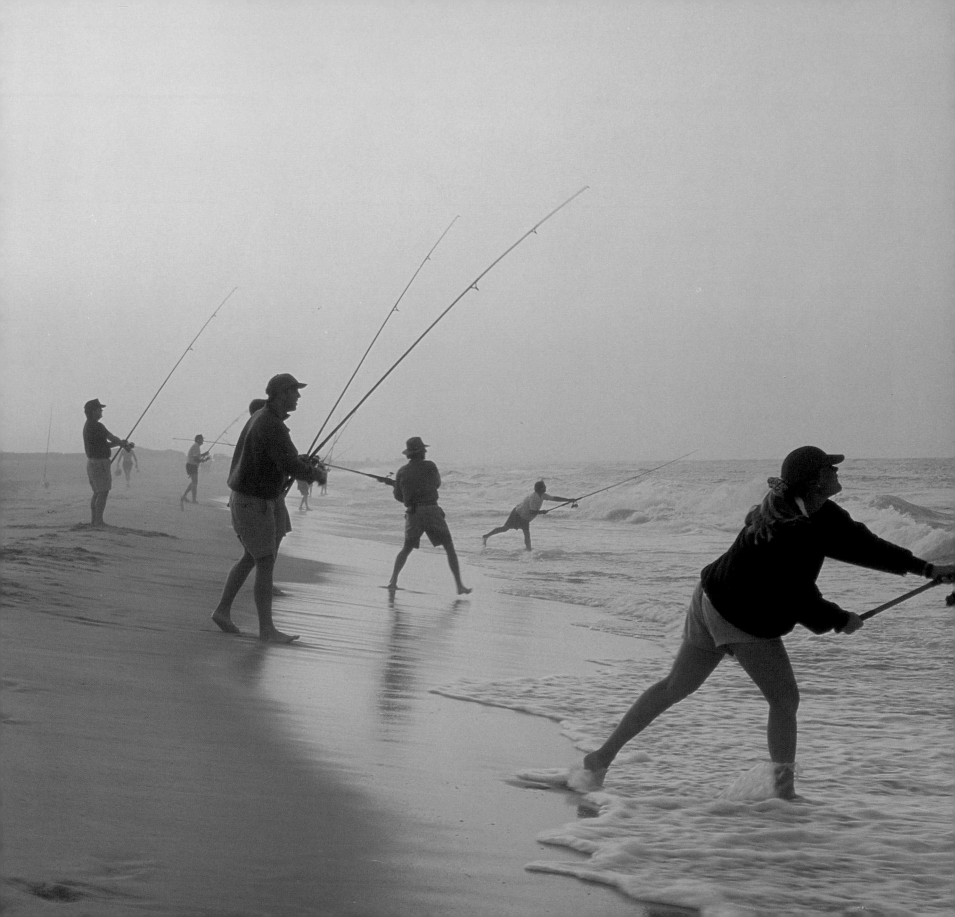

Gossip often gets in the way in small towns, but it also serves

a legitimate function. It enables you to know what's going on.

It's a network of news, and it helps provide some of the human fabric

that is much more important than cobblestones and gray shingles.

REVEREND TED ANDERSON
Unitarian Minister

Fishing for blues, Surfside

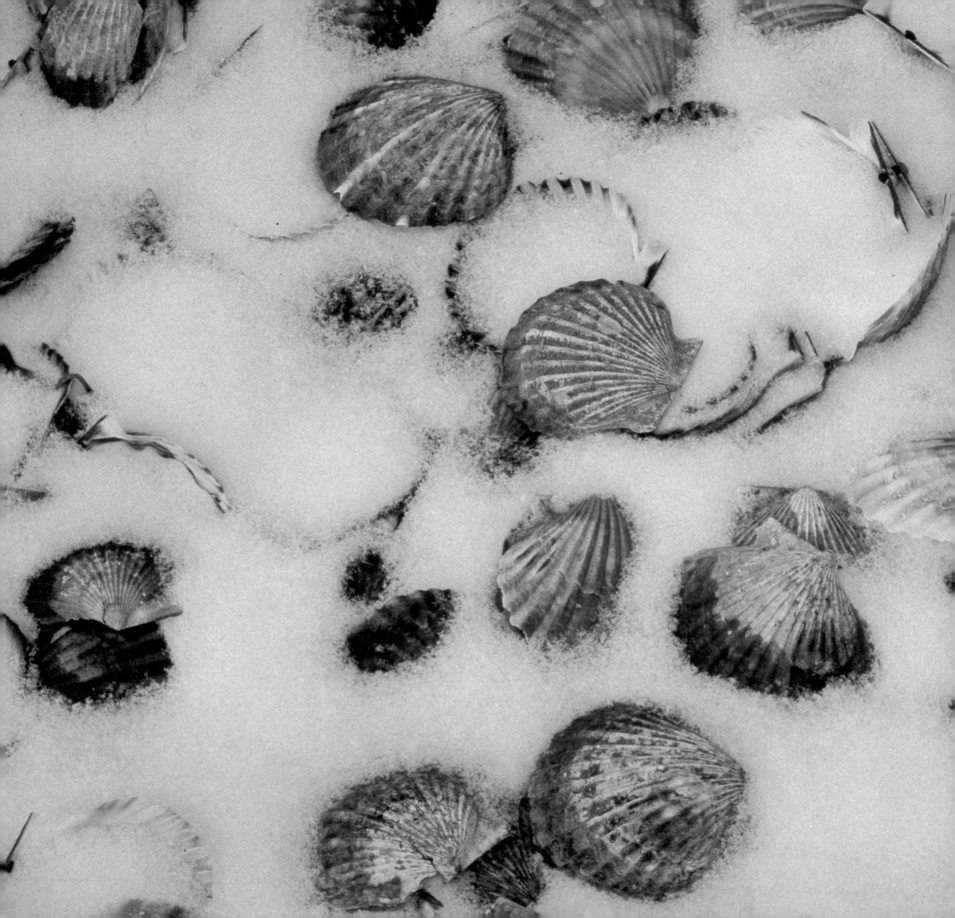

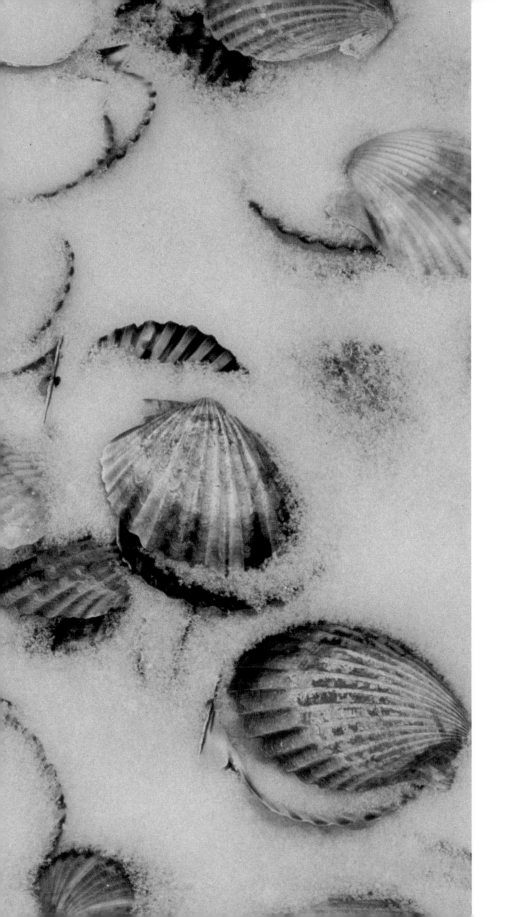

W I N T E R

There is a special magic in the wintertime.

It's a little bit too windy and a little bit too cold,

but I need that time to figure out where I've been

and where I am going.

JO GODWIN
Innkeeper

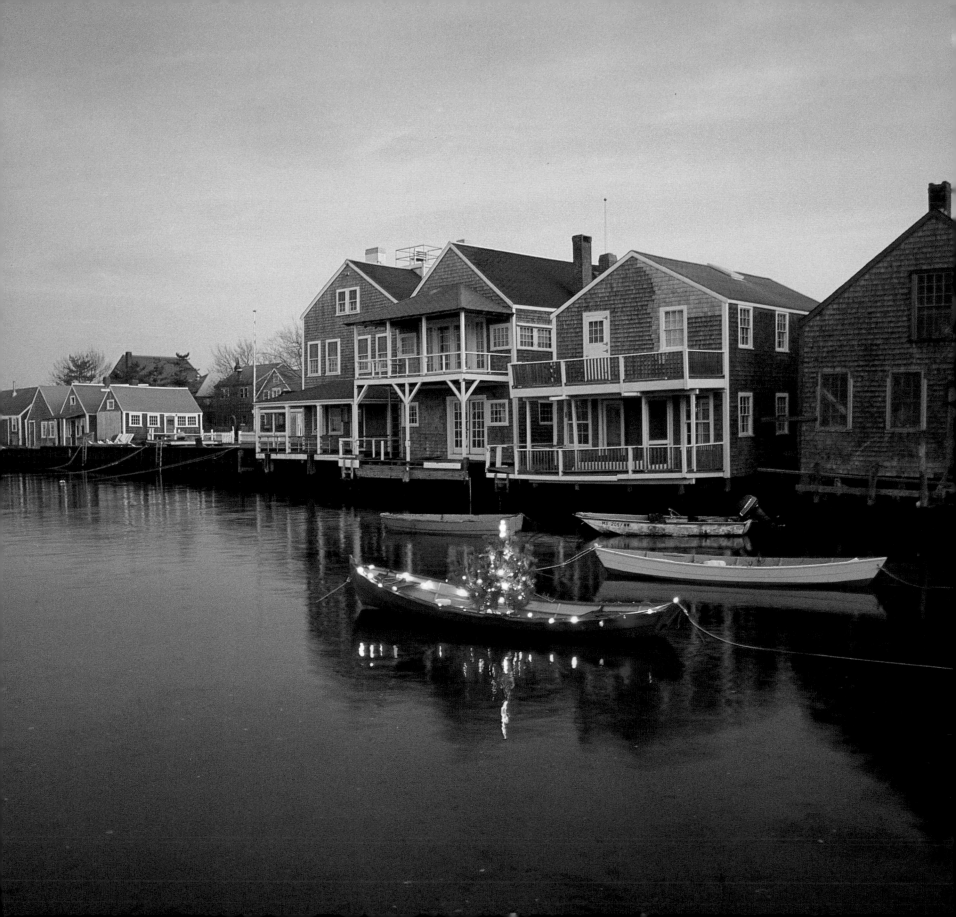

Main Street

Atheneum

It's what as a child you always dreamed

a Christmas should look like and be like.

THOM KOON
Hairdresser

Killen's dory,
Easy Street Basin

25

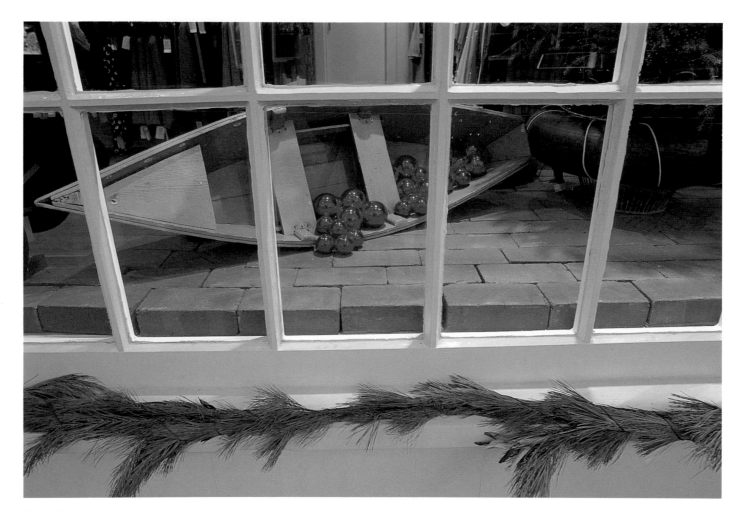

Zero Main

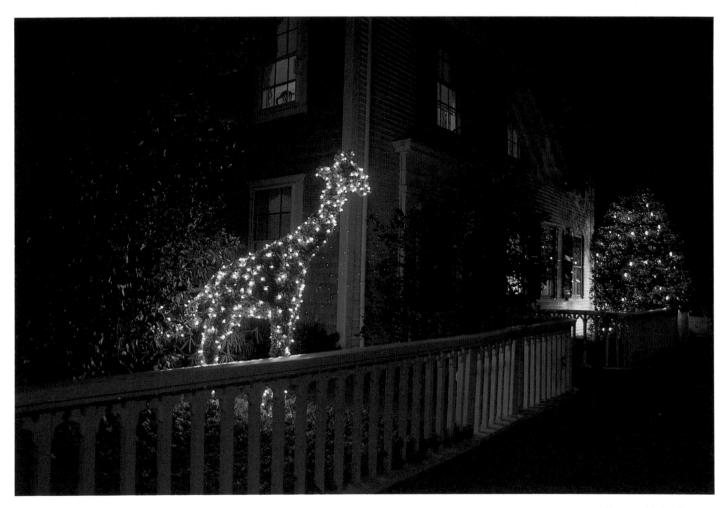

Upper Main Street

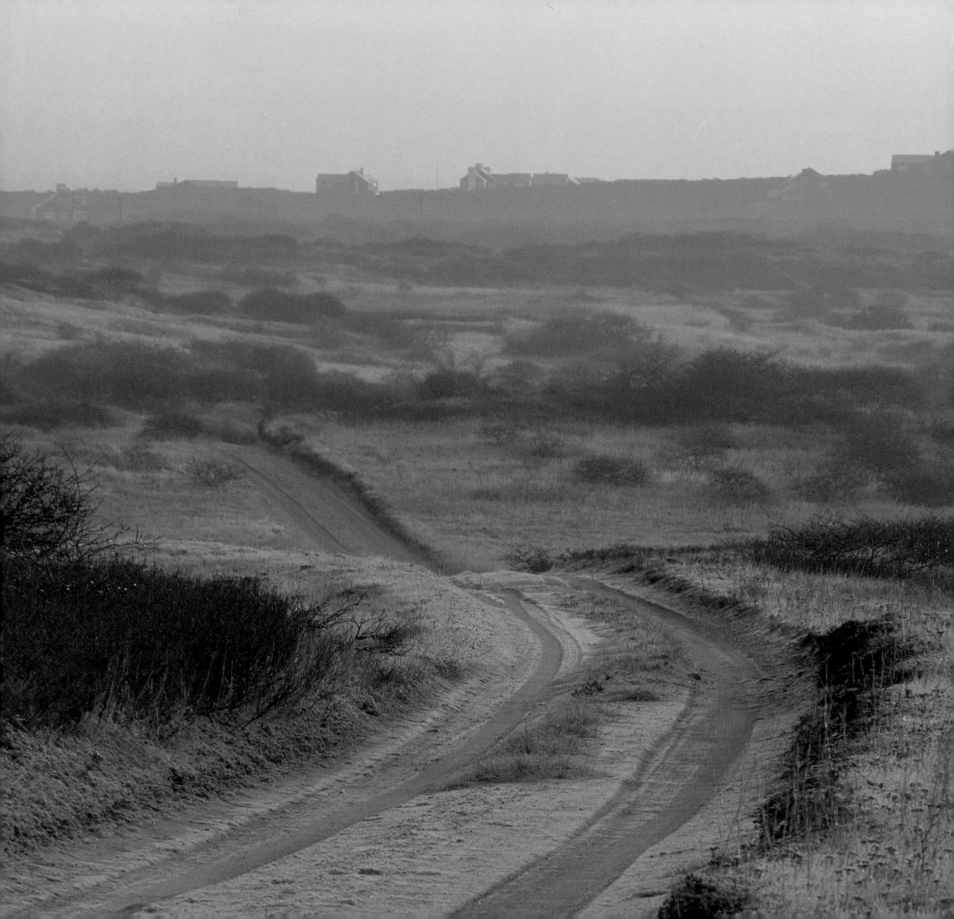

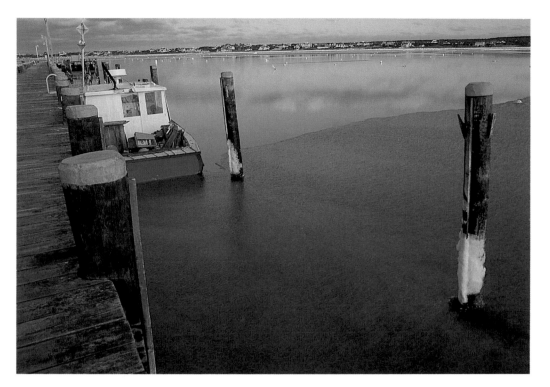

Town Pier

You have to get used to being cold when the wind blows because,

as the wind shifts, so does the climate . . . and so do our feelings.

MERLE ORLEANS
Columnist

The Moors

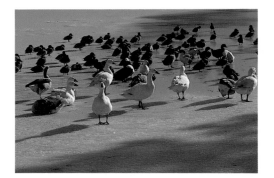

Polpis

Sesachacha Pond

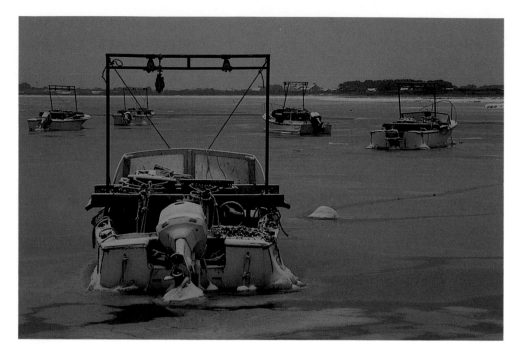

Scallop boats, Madaket

Scallop boat, Straight Wharf

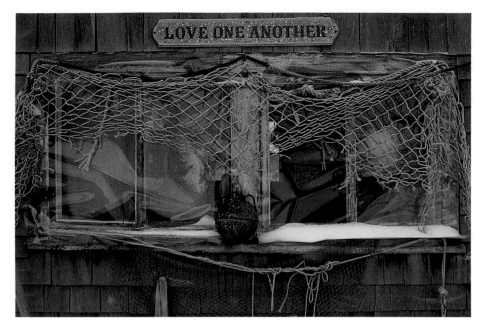

Dave Street

I first arrived on Nantucket by ferry in the dead of winter.

Coming into the wind around Brant Point and seeing that grayness

with only a few spots of color here and there

was an impression that I don't think I will ever forget.

BILL KLEIN
Town Planning Director

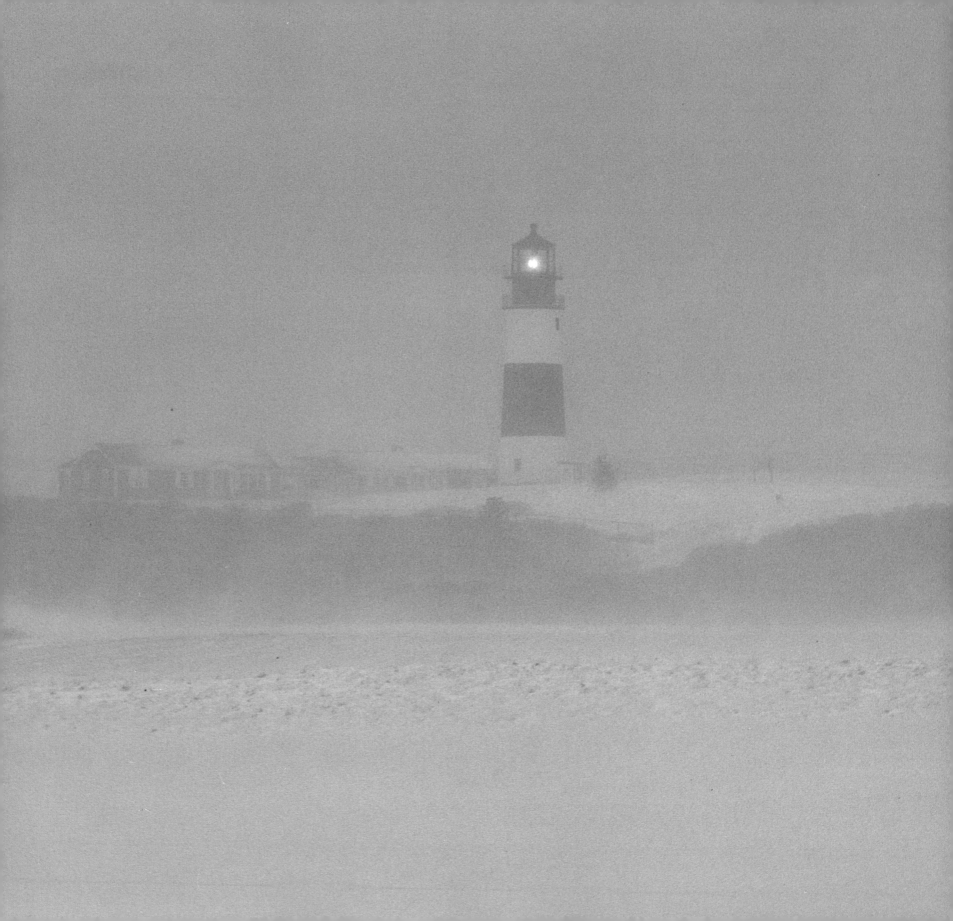

Sankaty Head Lighthouse

The Pacific Club

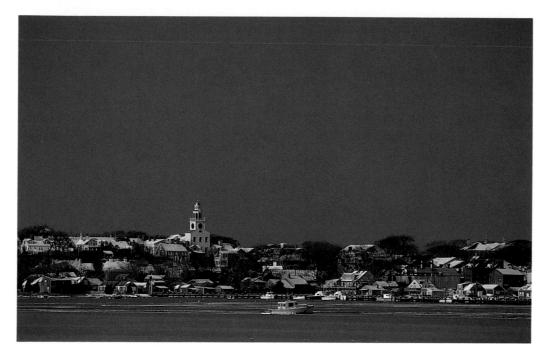

Town skyline

Weymouth Lane

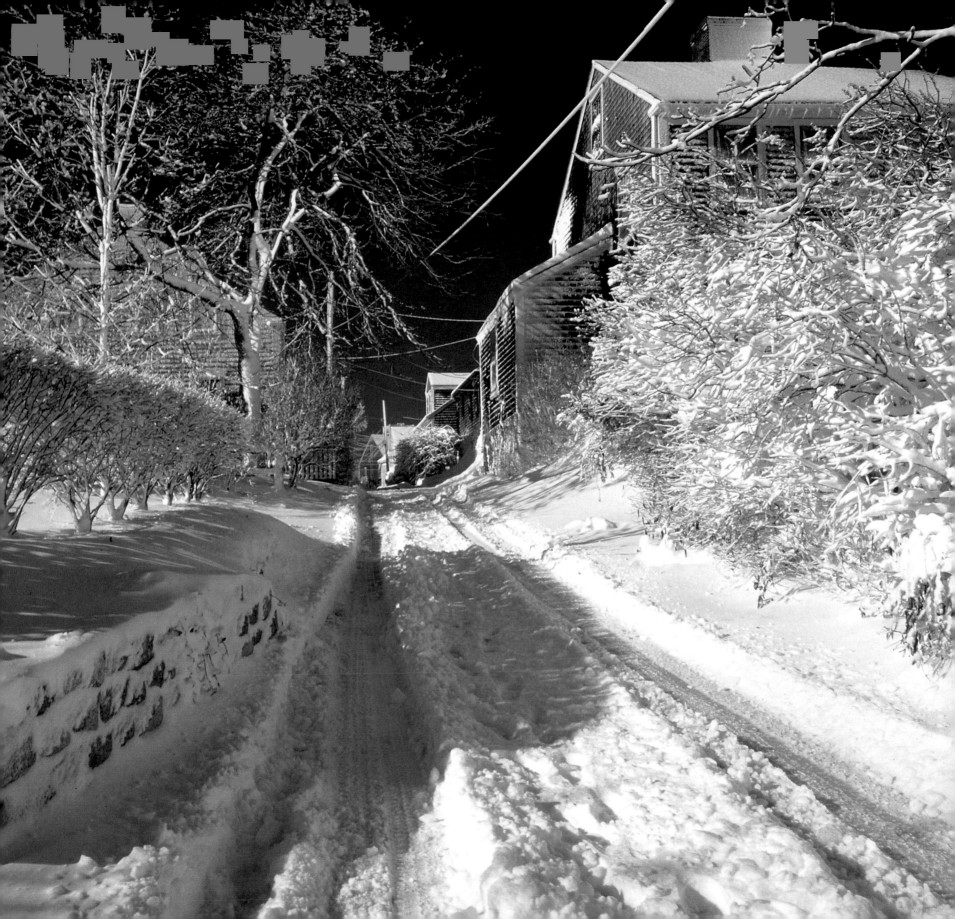

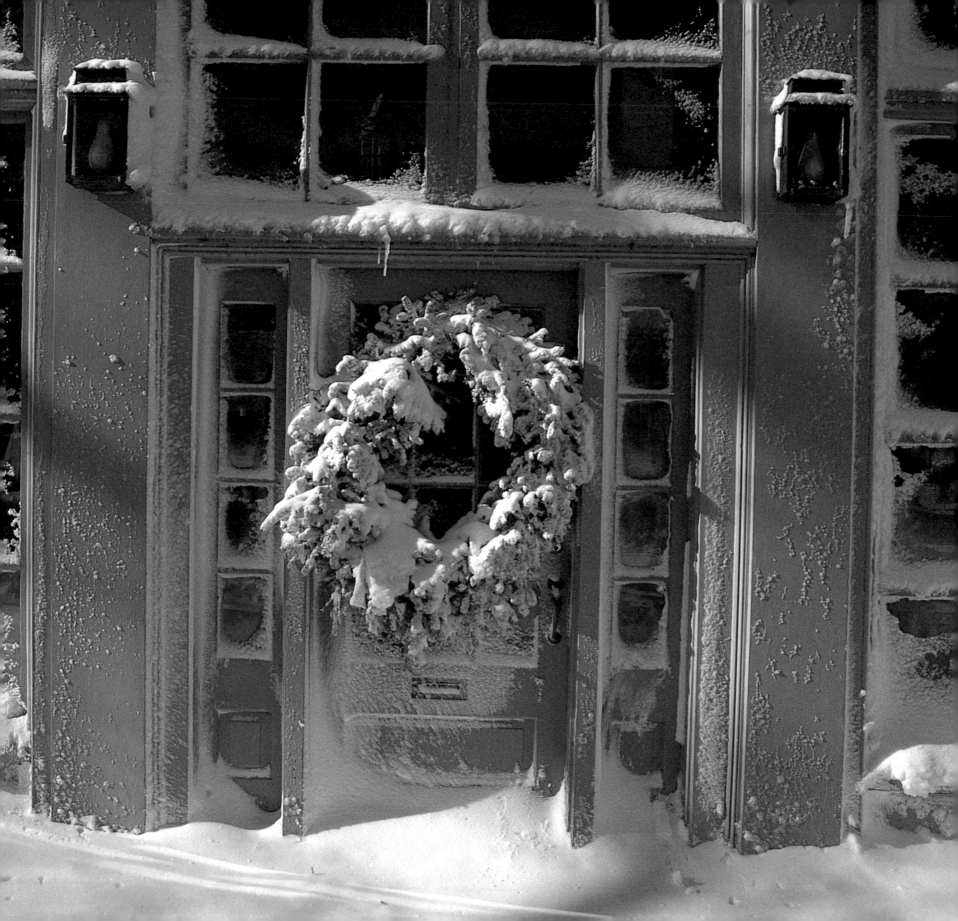

Bulletin board, the Hub

Federal Street

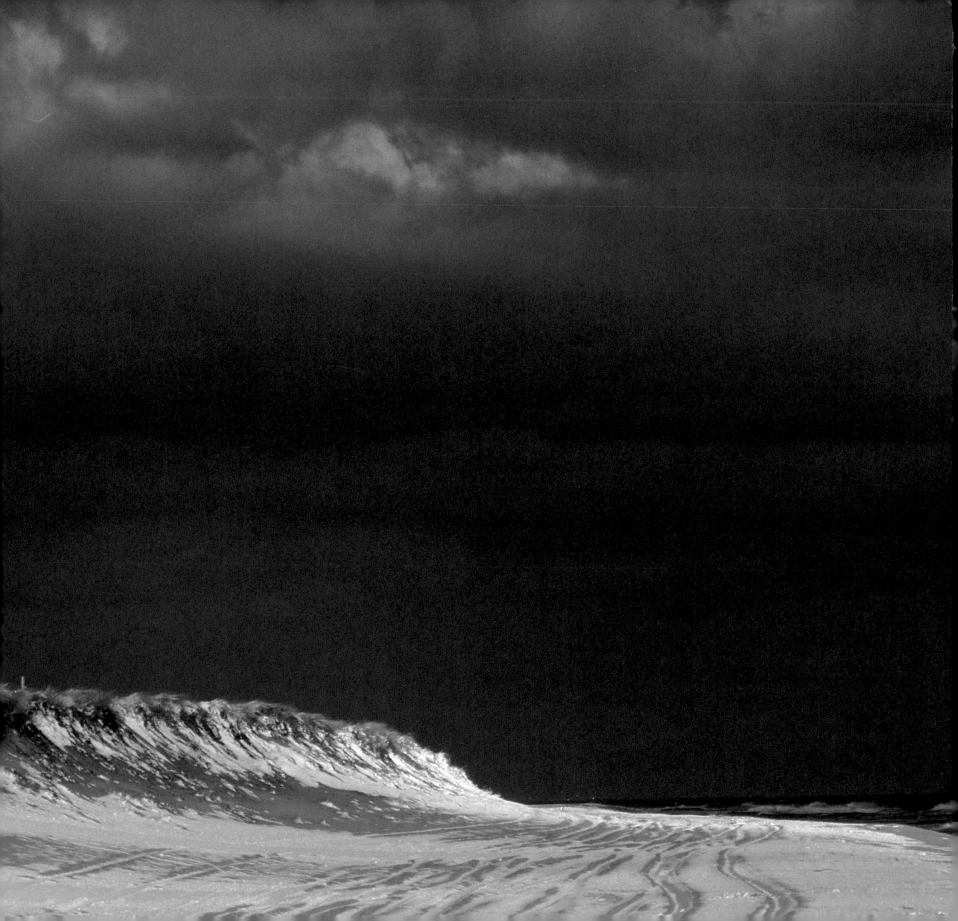

There's nothing like the dead of winter.

Take a ride on a cold winter's day

and watch the sun peek

through those gray-black clouds.

That's when you feel the isolation.

BOB MCGRATH
Groundskeeper
Nantucket Conservation Foundation

Surfside

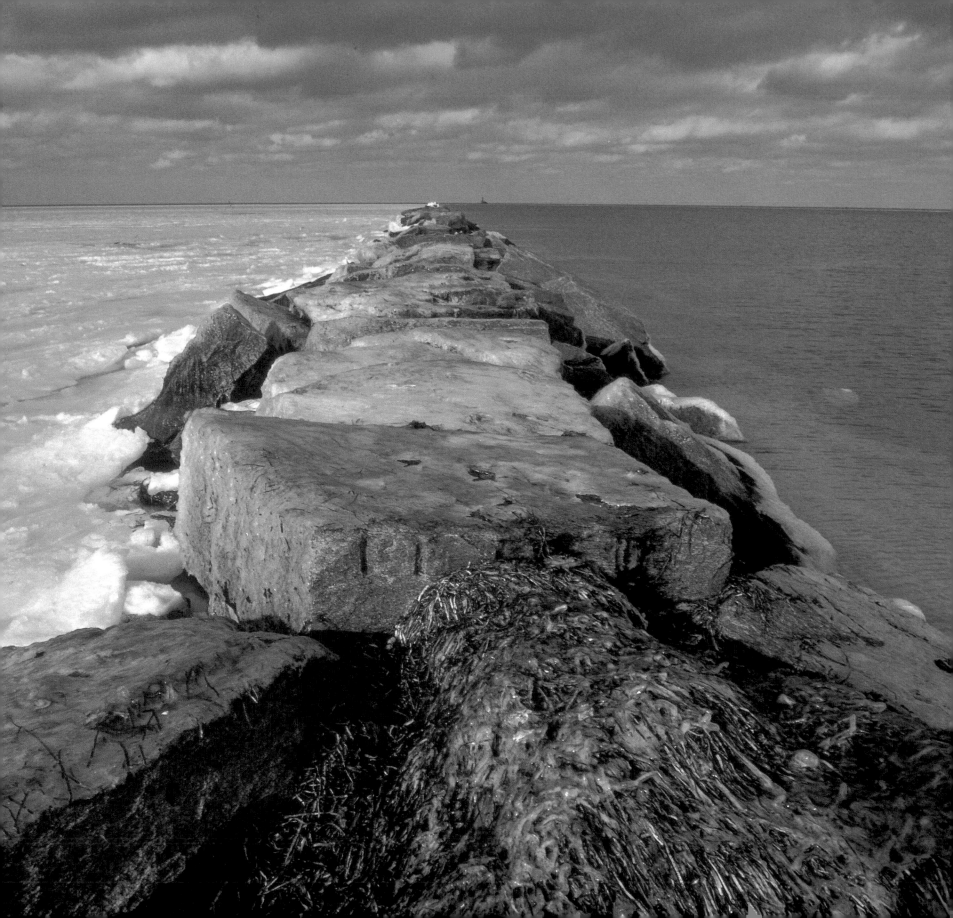

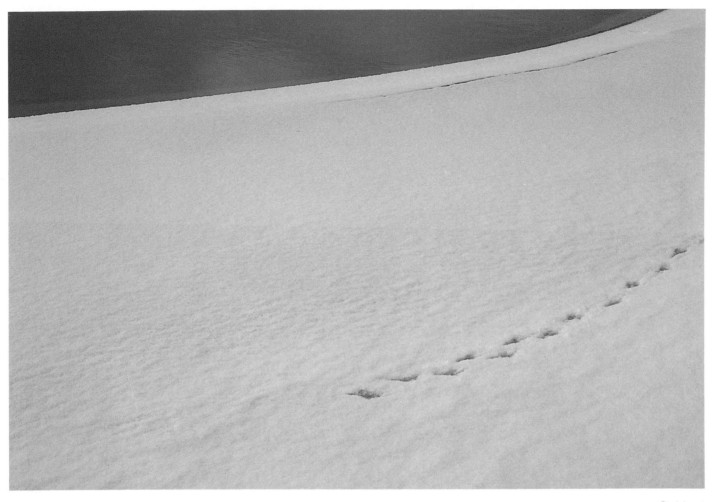

Quidnet

West Jetty

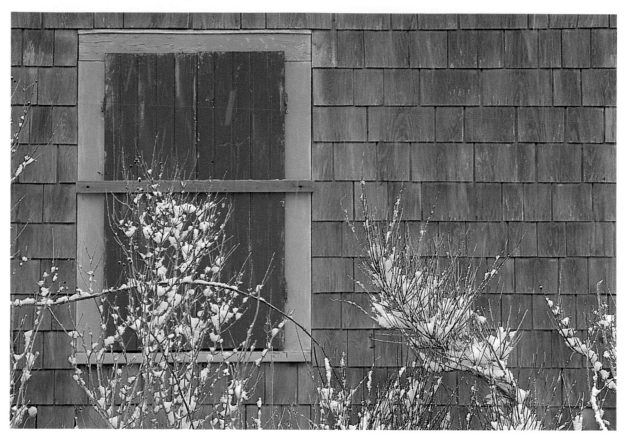

Siasconset

I like the quiet of winter. I go to the beach and look both ways and can't believe

there is not one living soul around.

STEVE SHEPPARD
Reporter

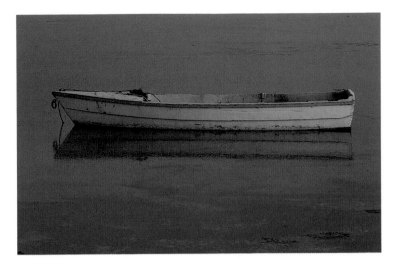

Nantucket Harbor

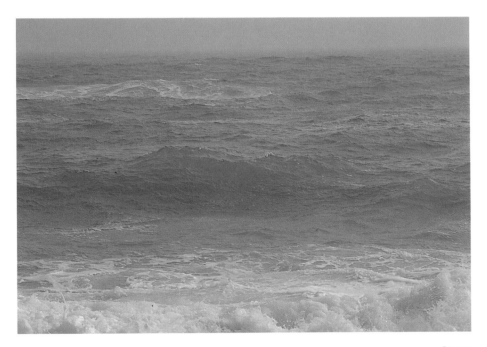

Cisco

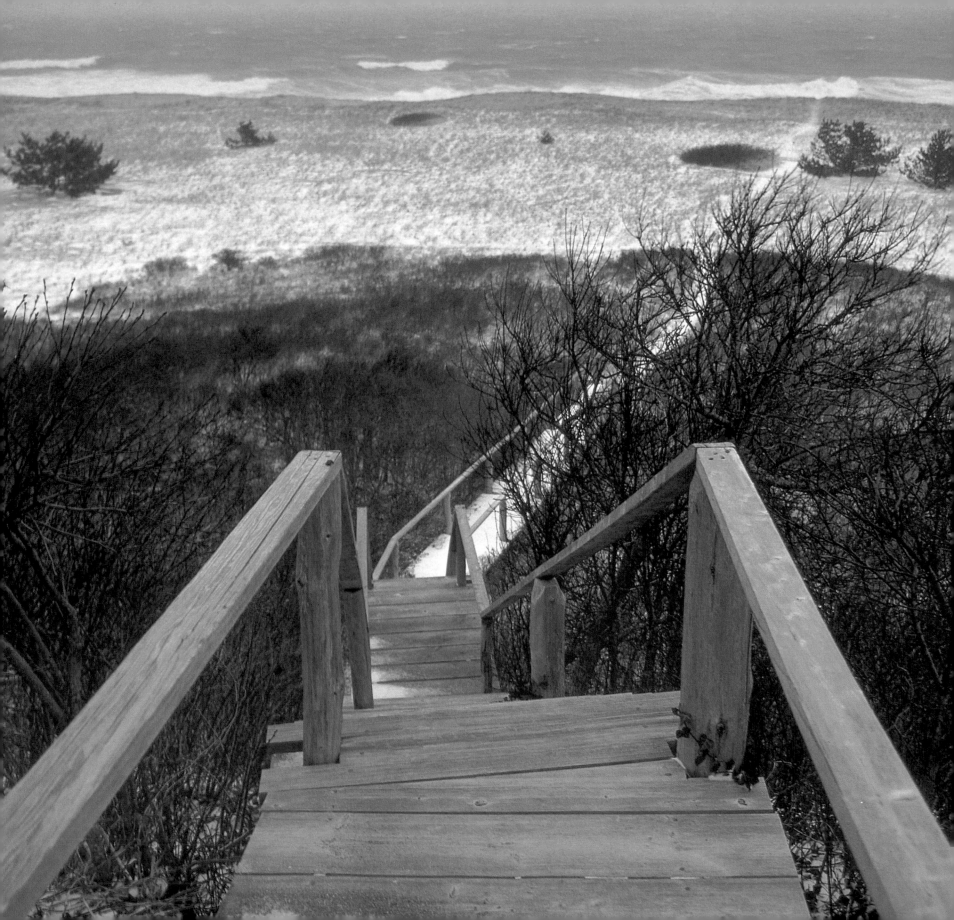

Weather vane, Siasconset

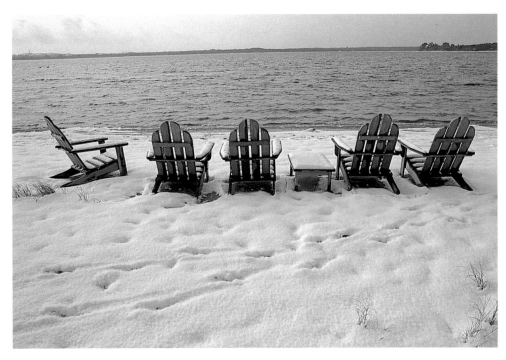

Quidnet

Siasconset walkway

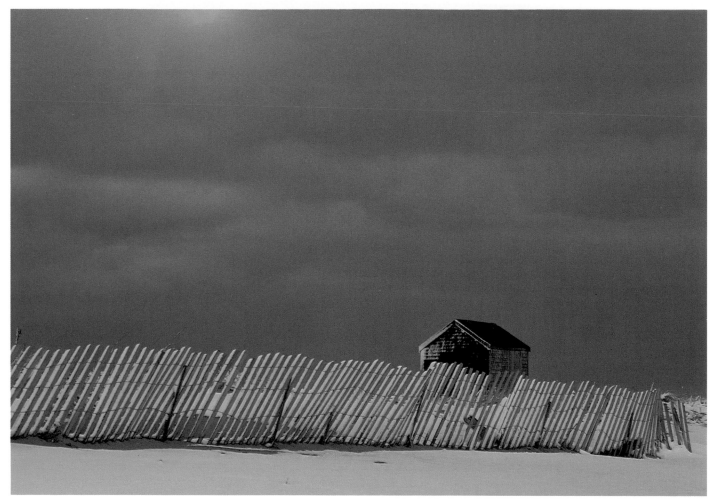

Miacomet

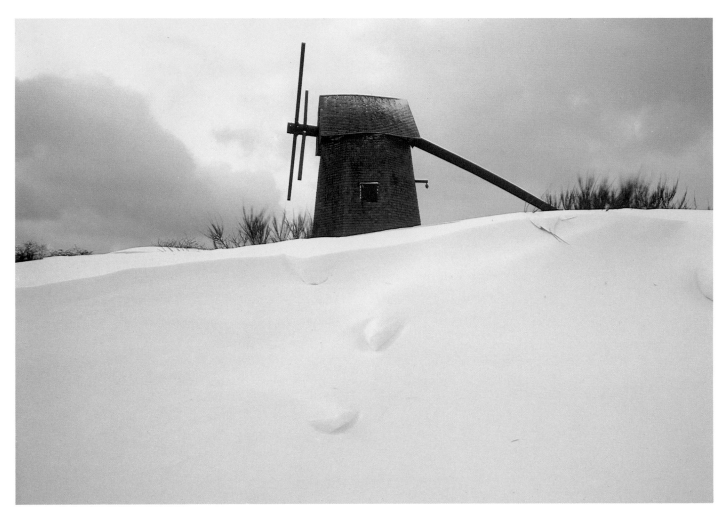

The Old Mill

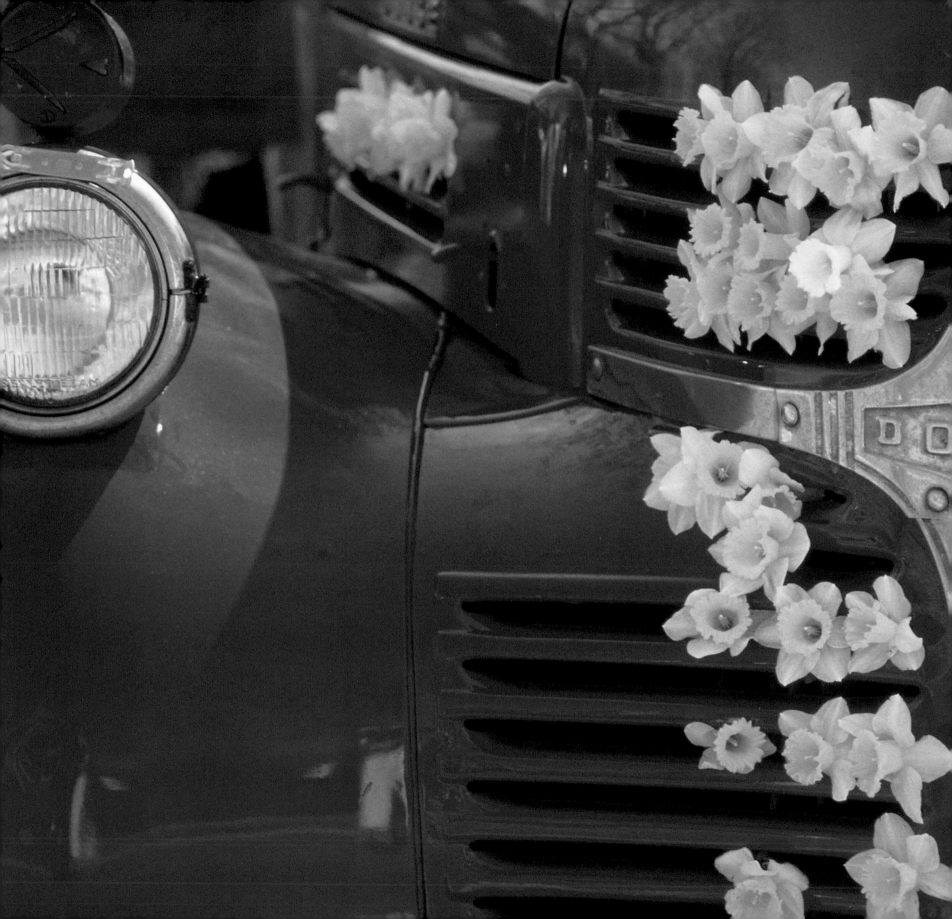

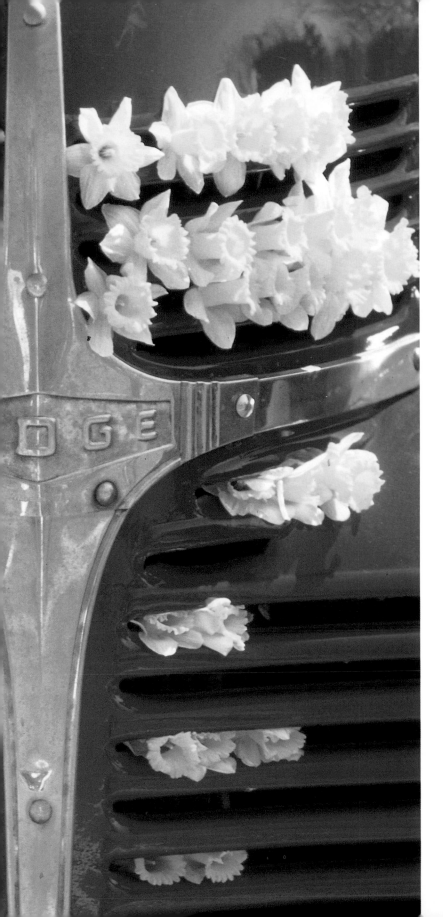

SPRING

I like to see the daffodils come up in the spring,

because then we know

there is hope that summer is coming.

MARY LOU RULEY
Mother

Broadway, Siasconset

Forsythia, Spring Street

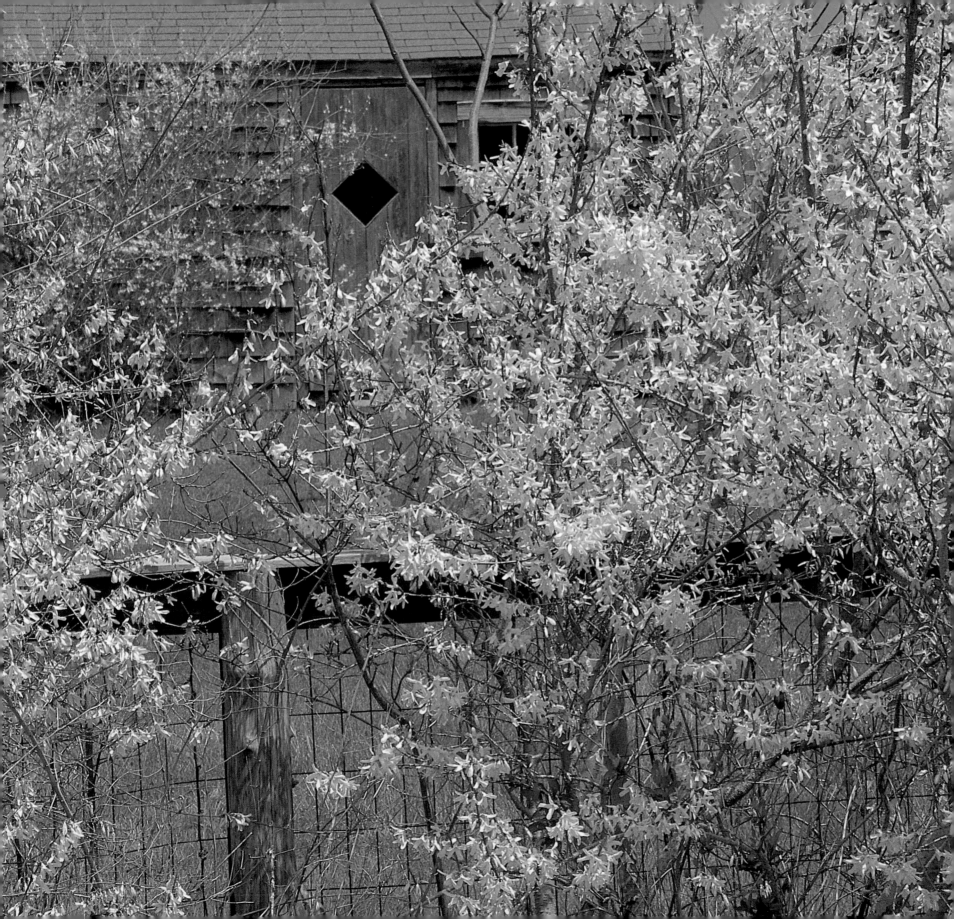

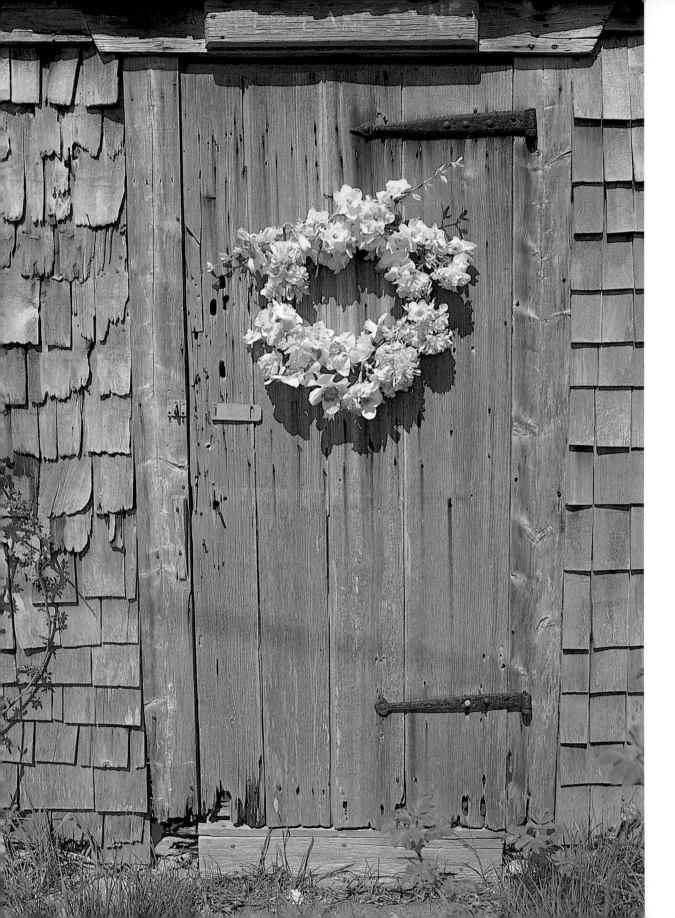

Auld Lang Syne,
Siasconset

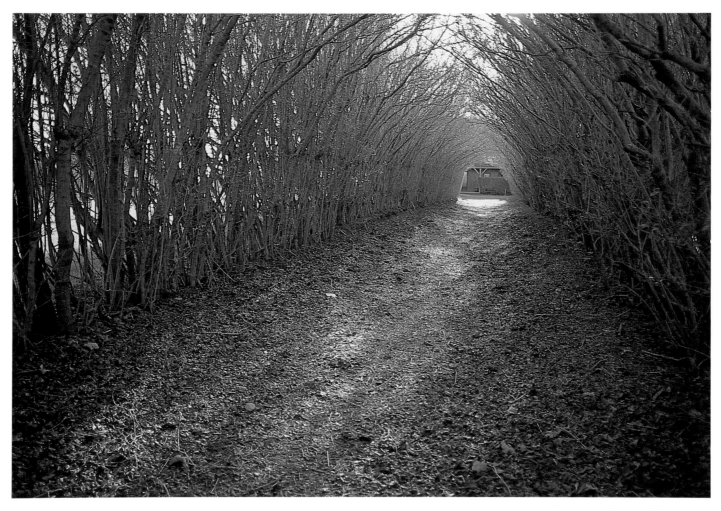

Privet walkway, Siasconset

Siasconset arbor

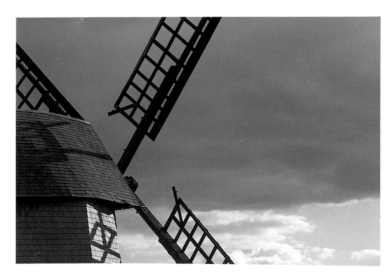

The Old Mill

The sky says spring is here and the air says spring is here

. . . but the temperature doesn't say spring is here.

FAITH VOLLANS
Firewood Dealer

57

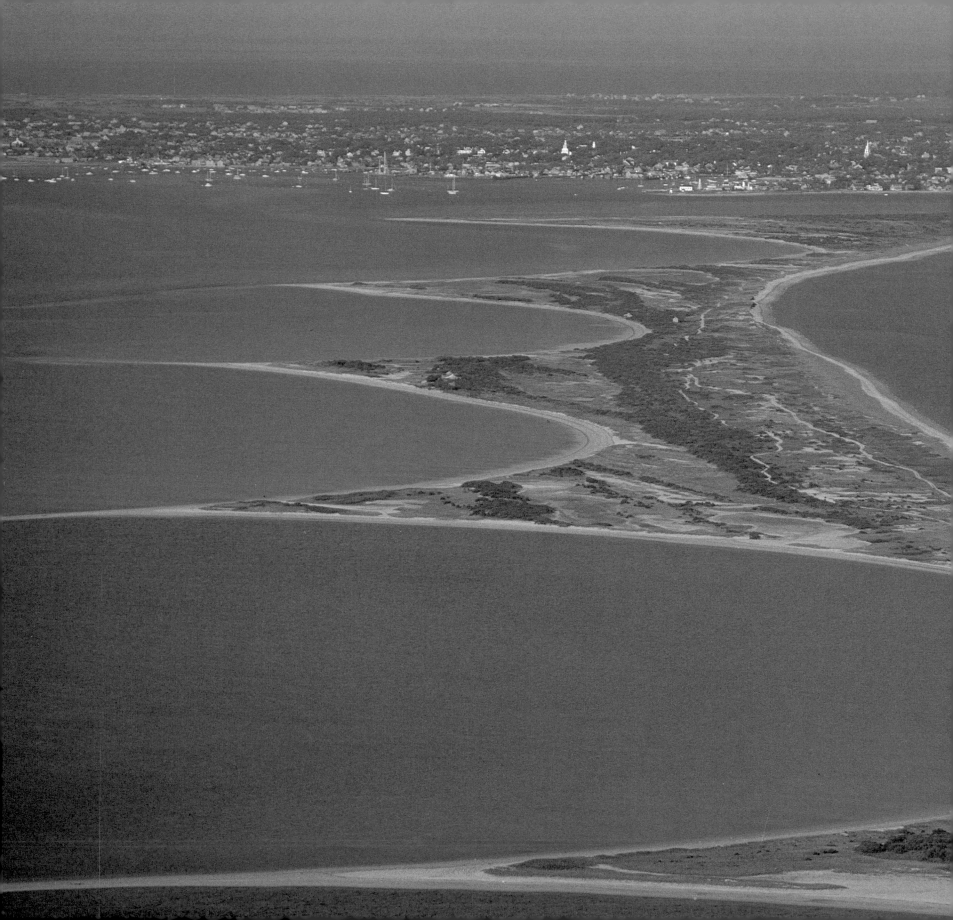

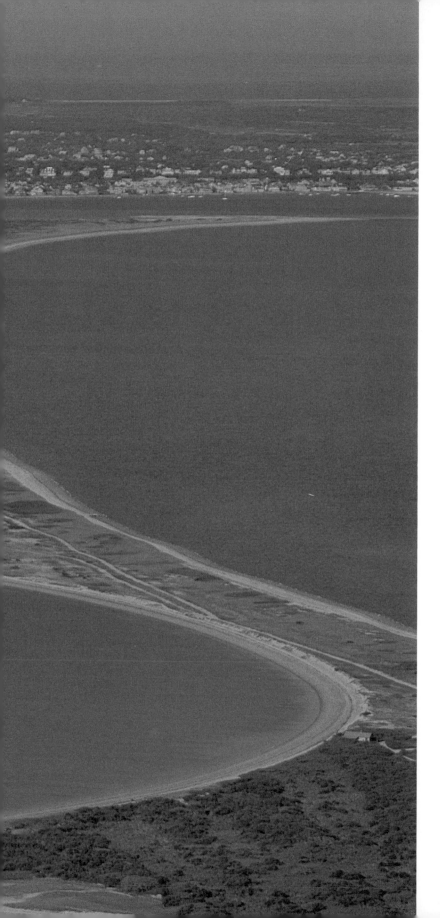

Coatue

We are thirty miles out to sea,

and there is a wonderful openness around us.

I've never known any place else

that inspires such devotion.

SARAH CHASE
Cookbook Author

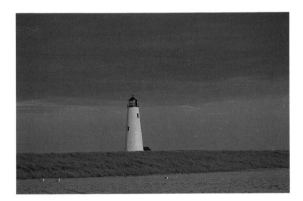

Great Point Lighthouse

Stairwell, Great Point Lighthouse

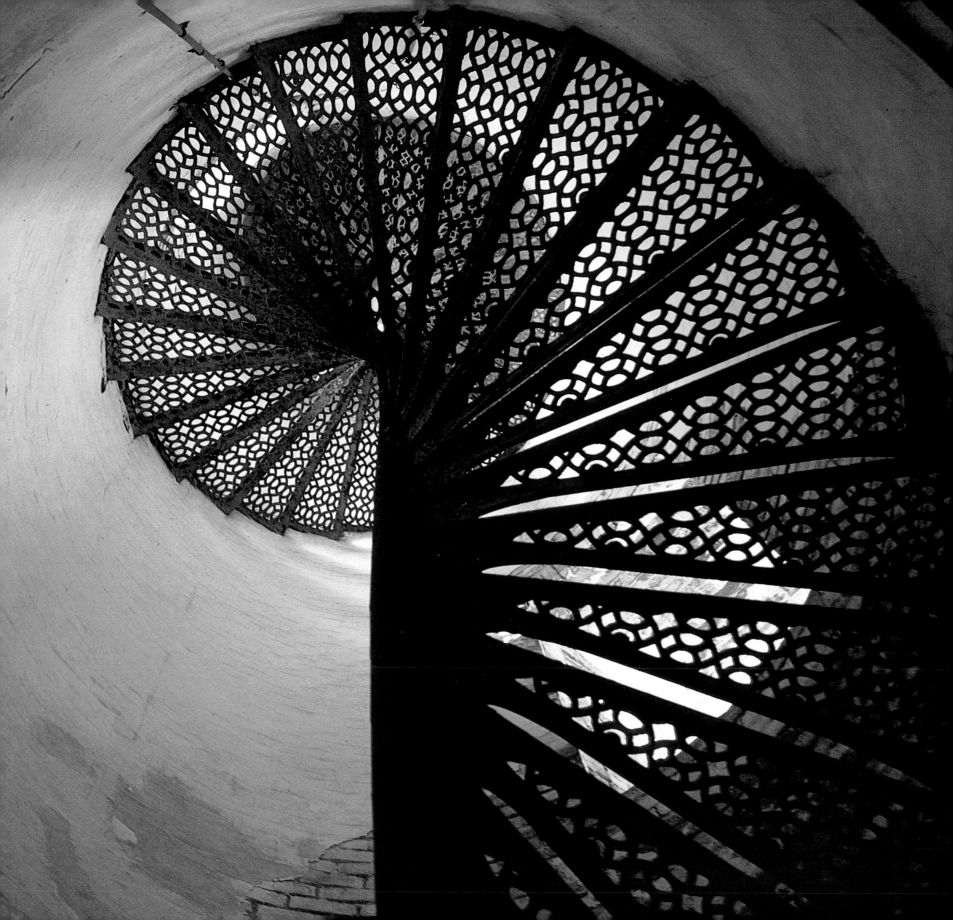

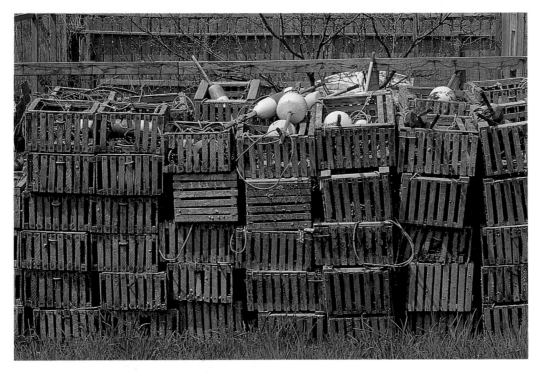

Lobster pots, Williams Lane

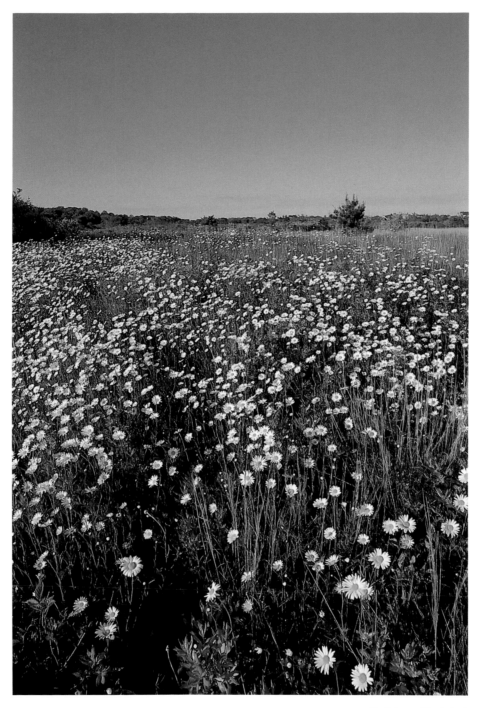

Daisies, Madaket

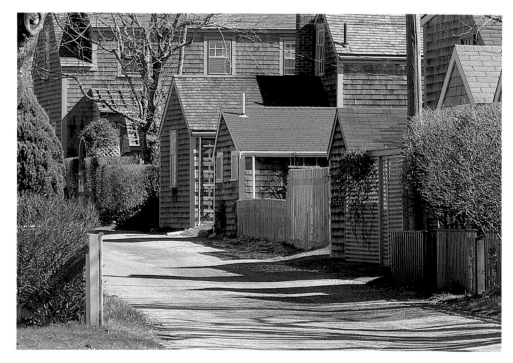

Siasconset

We all know each other, and we get along really well here.

Stone Alley

It's such a tiny island we have to be friends.

MARTHA CARY
Fifth Grade

Wisteria, Union Street

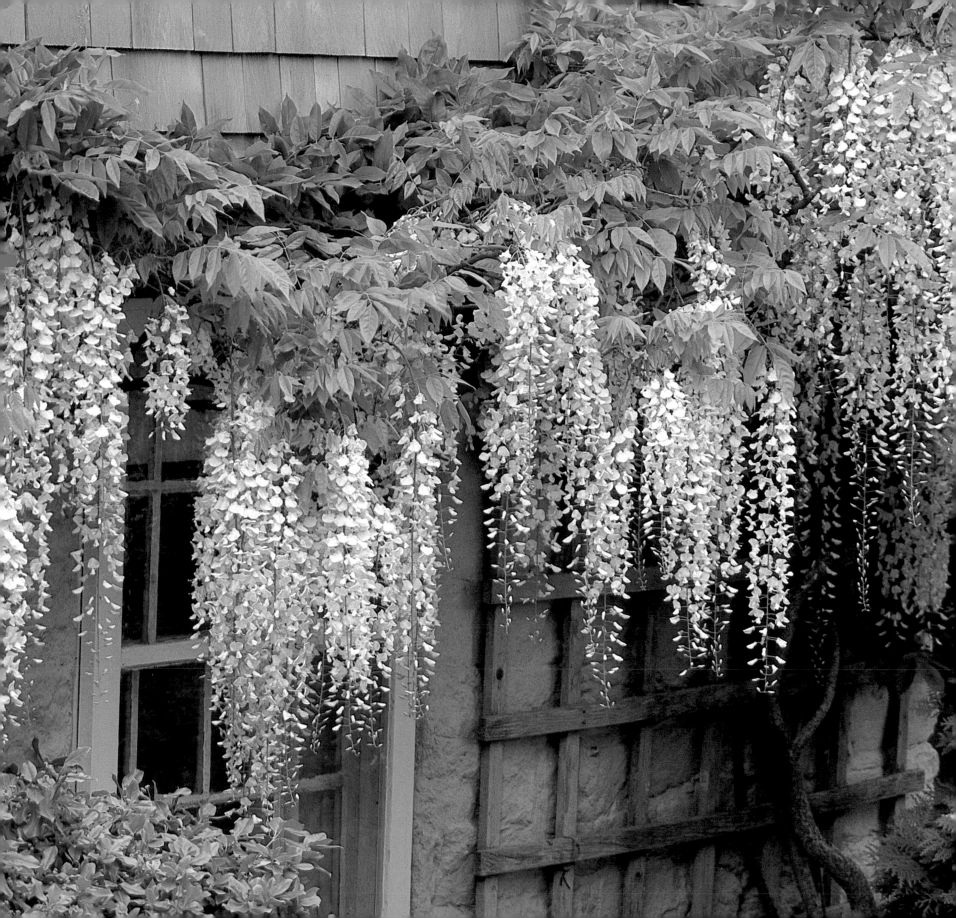

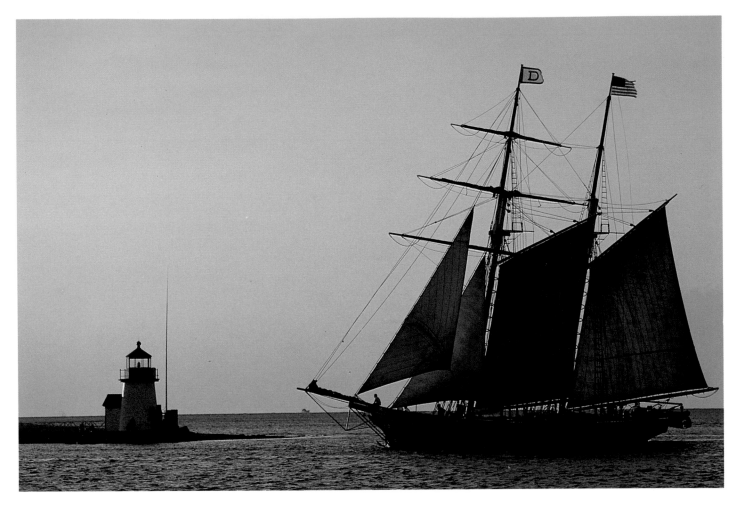

Shenandoah

I think what made me stay here is that I found a piece of America that I didn't think existed anymore.

CHERYL BARTLETT
Nurse

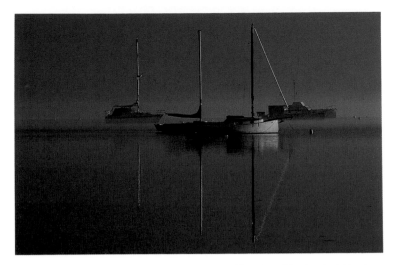

Sunrise, Nantucket Harbor

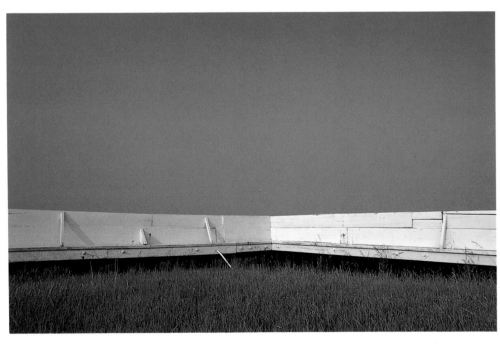

Sea wall, Hulbert Avenue

Main Street

Hinckley Lane

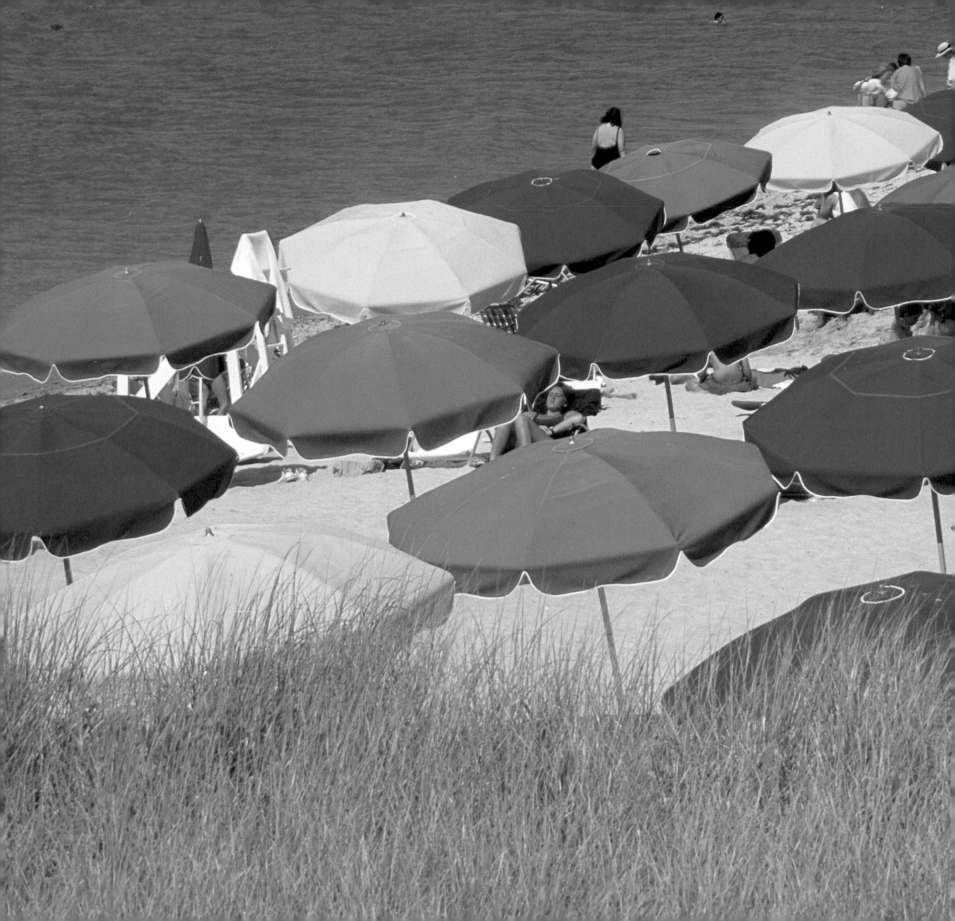

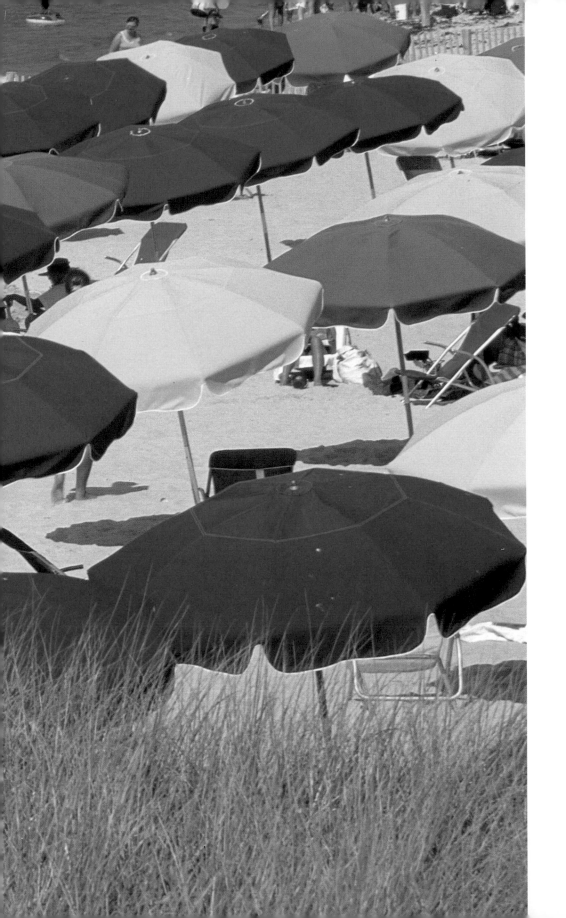

S U M M E R

No matter how crowded

it is in the summertime,

there is always a place

where you can go to be alone.

SARAH CHASE
Cookbook Author

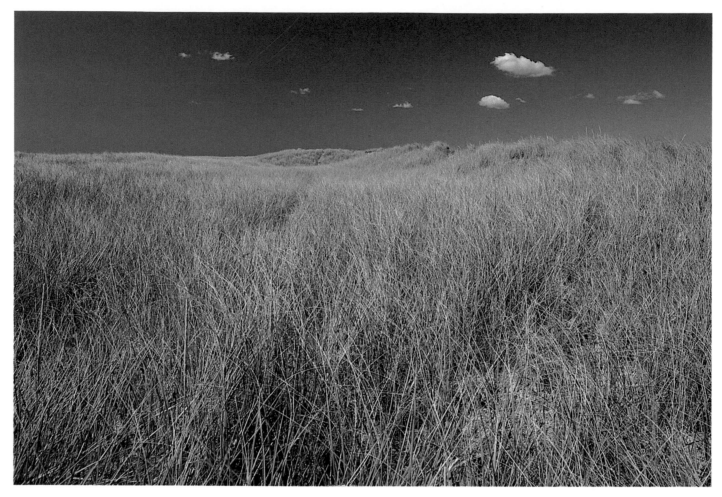

Miacomet

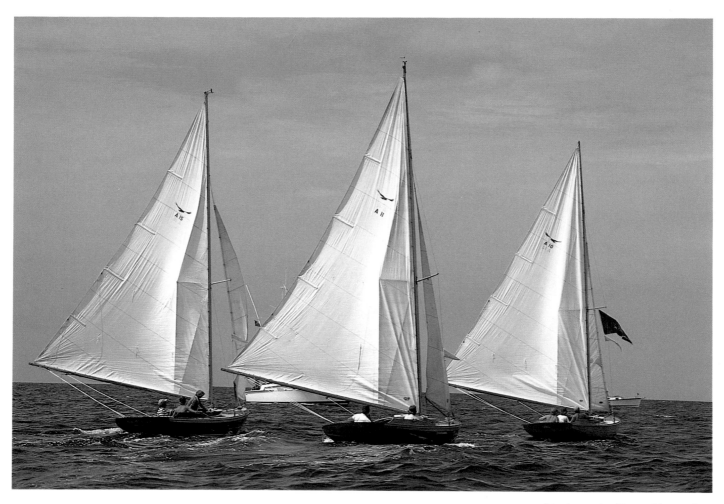

Alerions, built on Nantucket

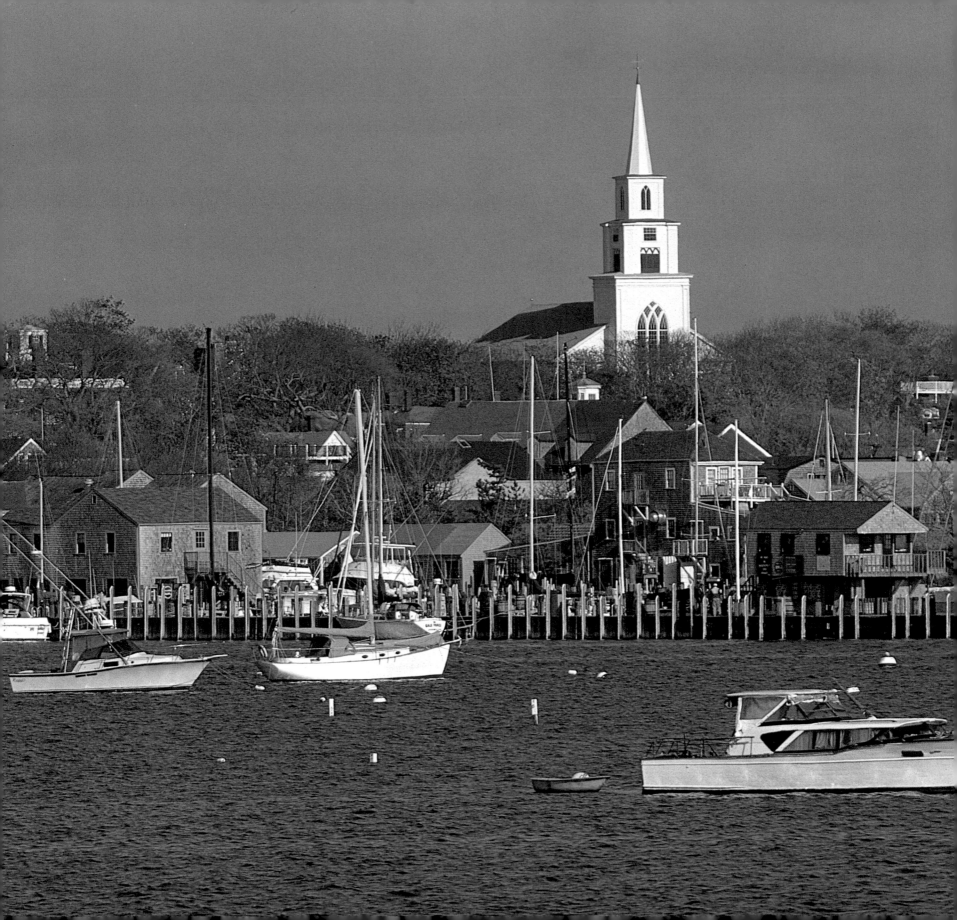

North Church

India Street

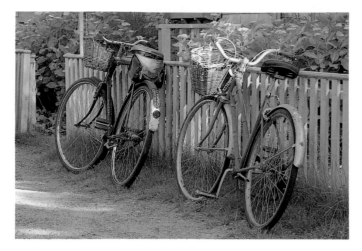

Siasconset

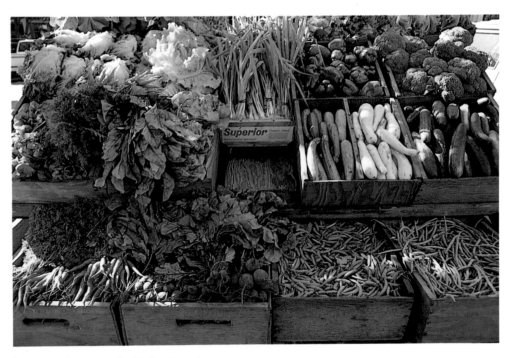

Bartlett Farm truck, Main Street

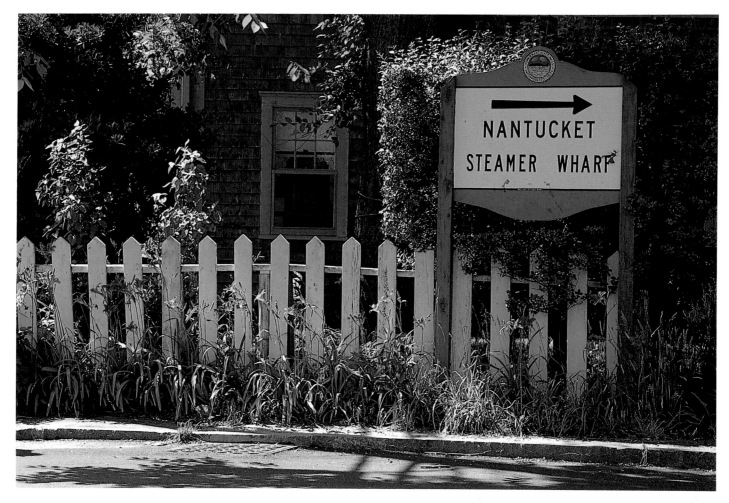

Francis Street

I always figure you know the summer season is beginning

when you see someone driving the wrong way down Main Street.

GEORGE MURPHY
Artist

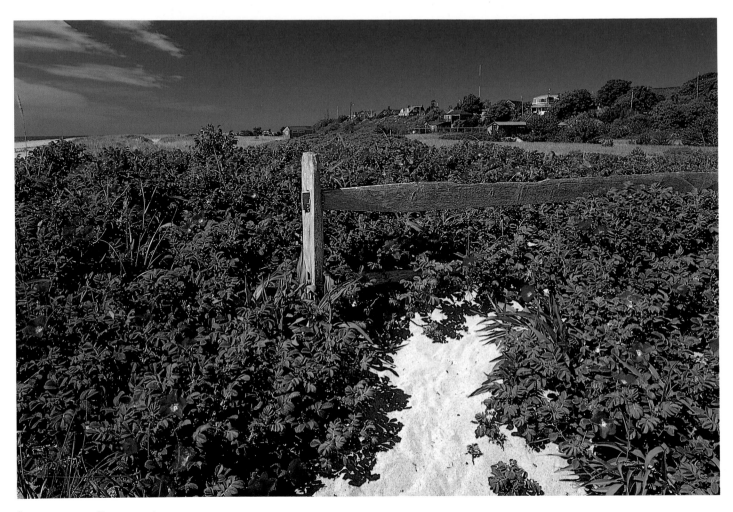

Rosa rugosa, Siasconset

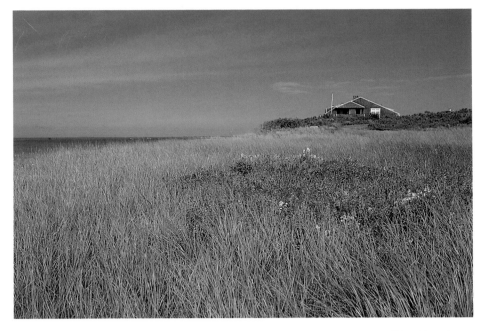

Hinckley Lane

Rosa rugosa, Washington Street

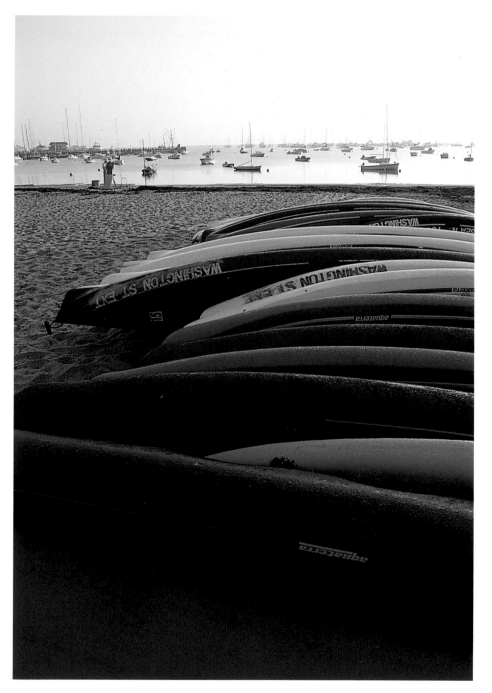

Kayaks, Nantucket Harbor

Sunfish,
Jetties Beach

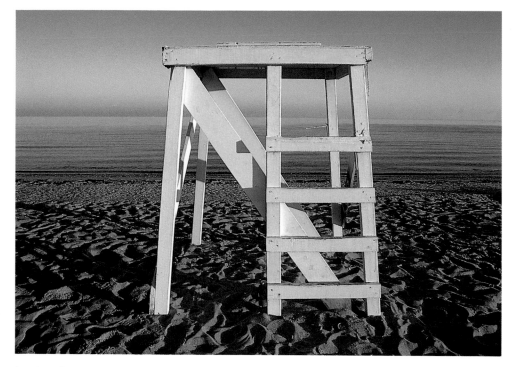

Jetties Beach

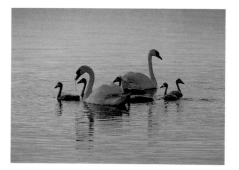

Sesachacha Pond

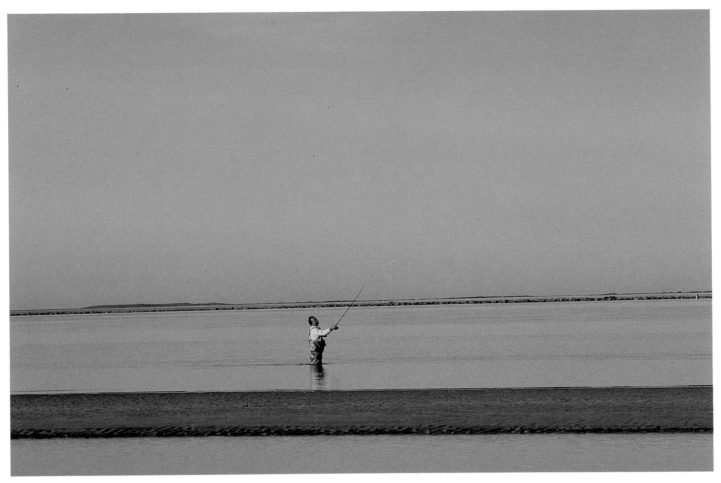

We have everything a dreamer would want.

REVEREND TOM RICHARD
Congregationalist Minister

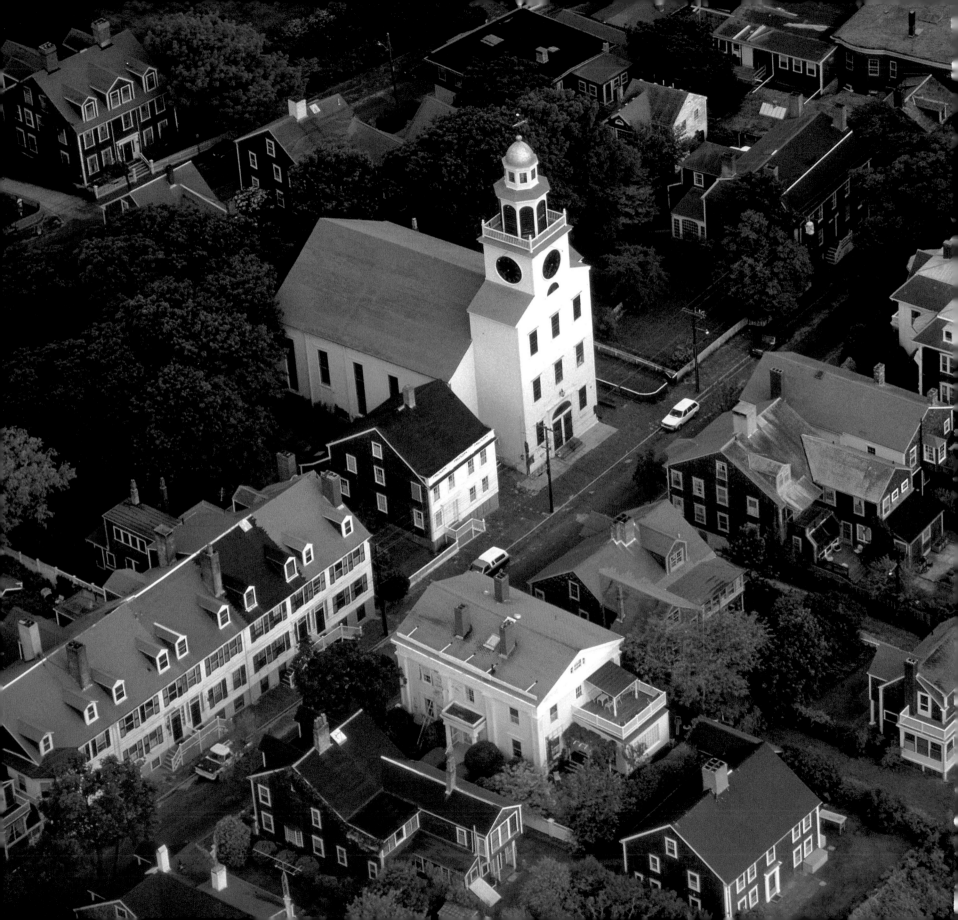

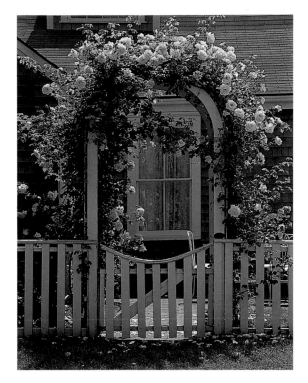

New Dawn roses, Siasconset

South Church

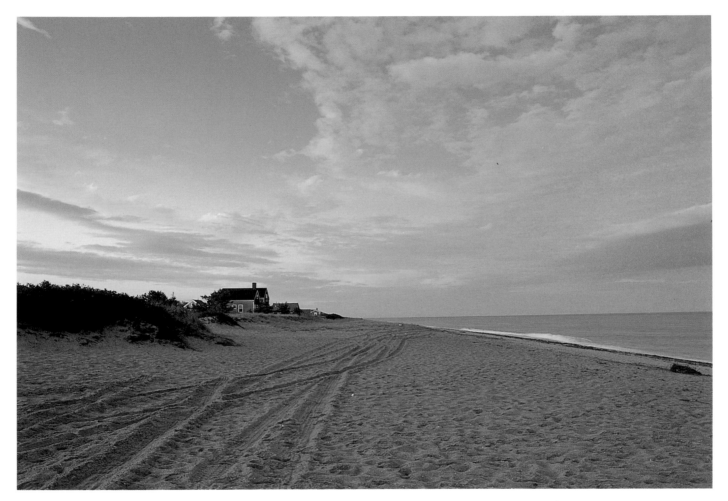

Siasconset

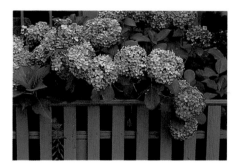

Hydrangeas, North Liberty Street

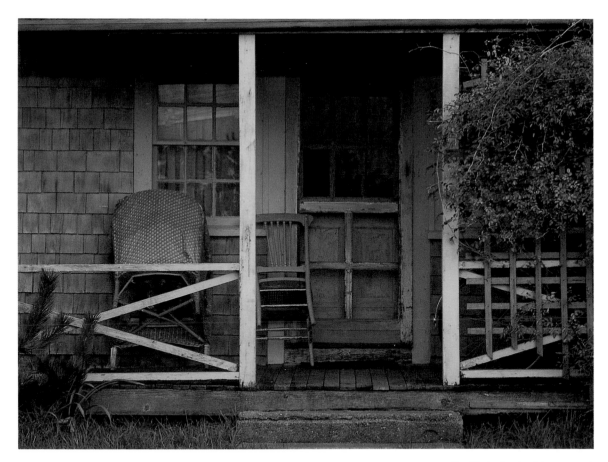

Codfish Park, Siasconset

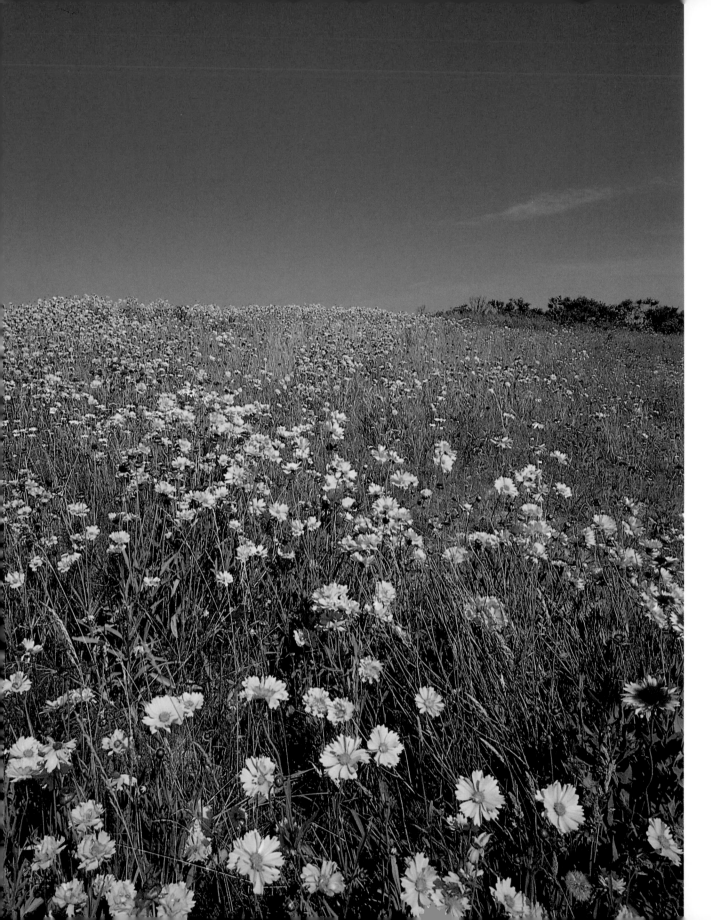

Coreopsis,
Sankaty Bluff

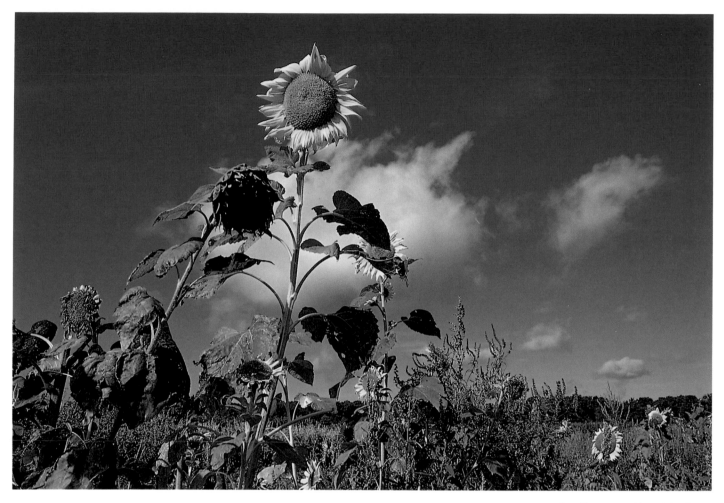

Why do I live here? It's pleasing to the eye and the soul.

The streets are quiet, the stars are brighter, and the sky is bigger.

JACK WARNER
Author

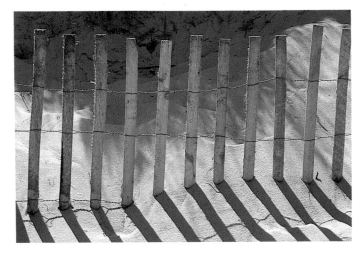

Snow fence, Cliffside

Jetties Beach

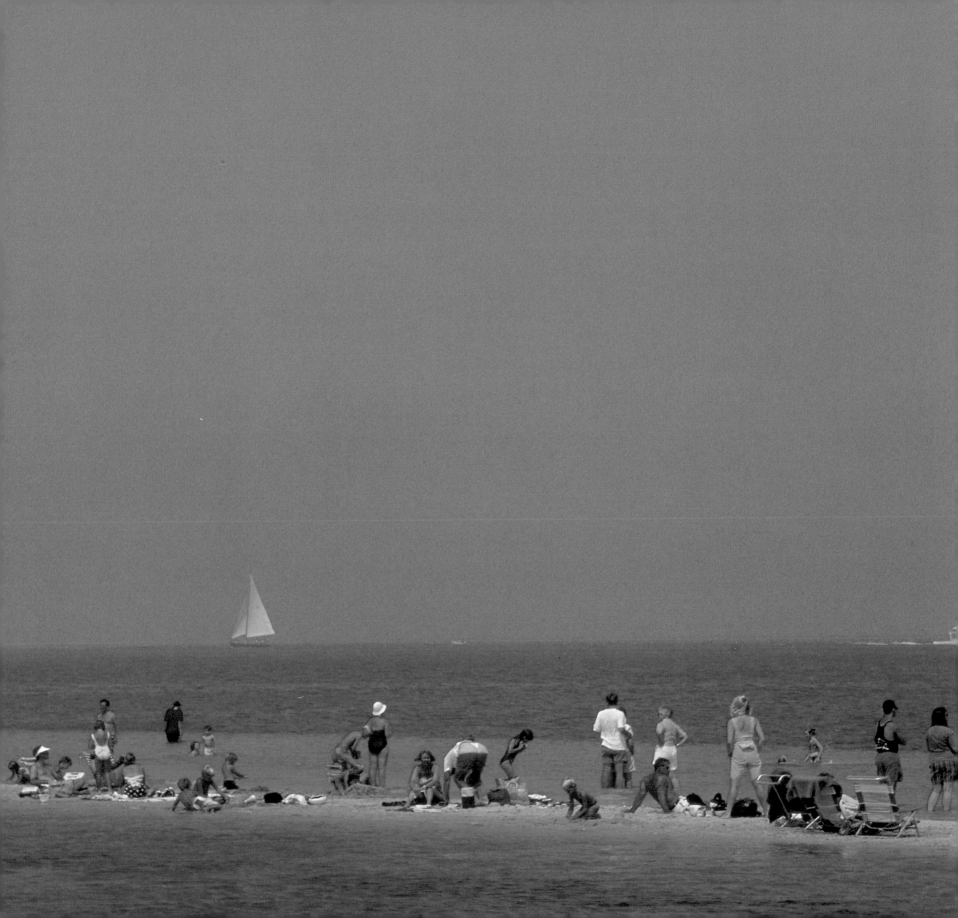

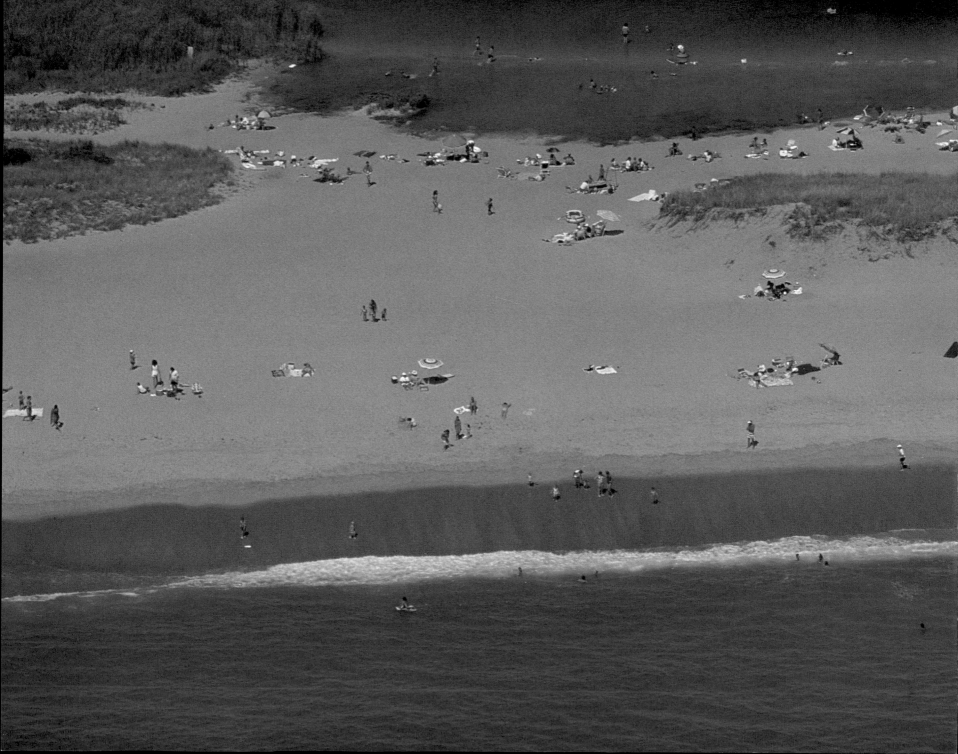

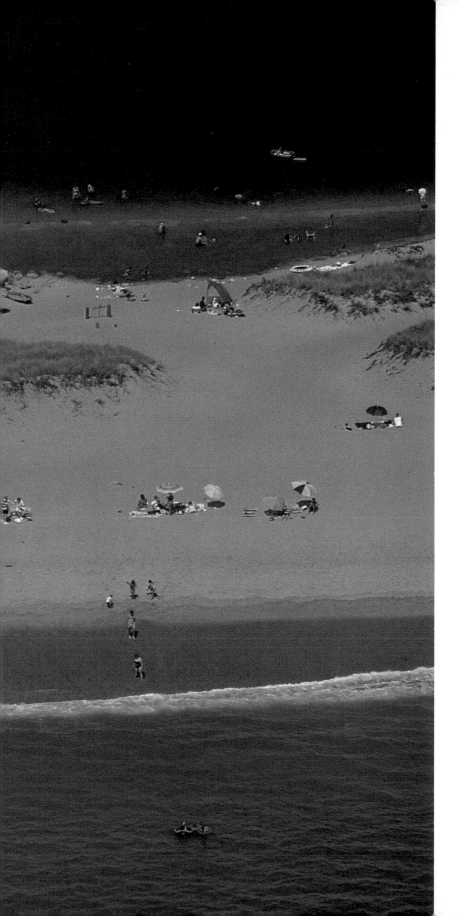

Miacomet

I was in an airport in Athens, Greece,

standing behind this lady in the ticket line,

and she had a lightship basket.

I tapped her on the shoulder and said,

"Ma'am, you're from Nantucket, so am I,"

and she said, "My dear, I'm from 'Sconset.'"

SKIP CABOT
Town Selectman

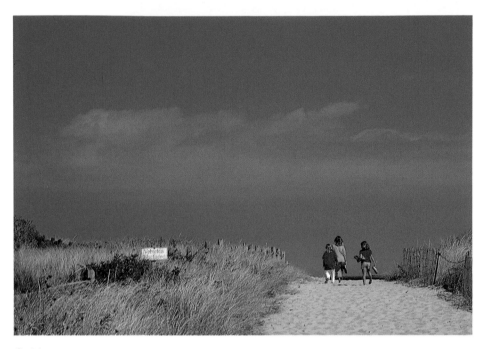

Quidnet

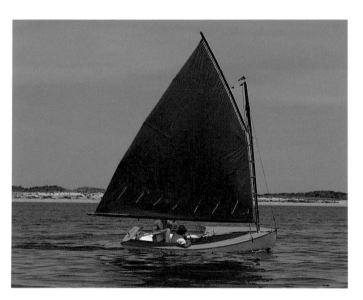

Rainbow, Nantucket Harbor

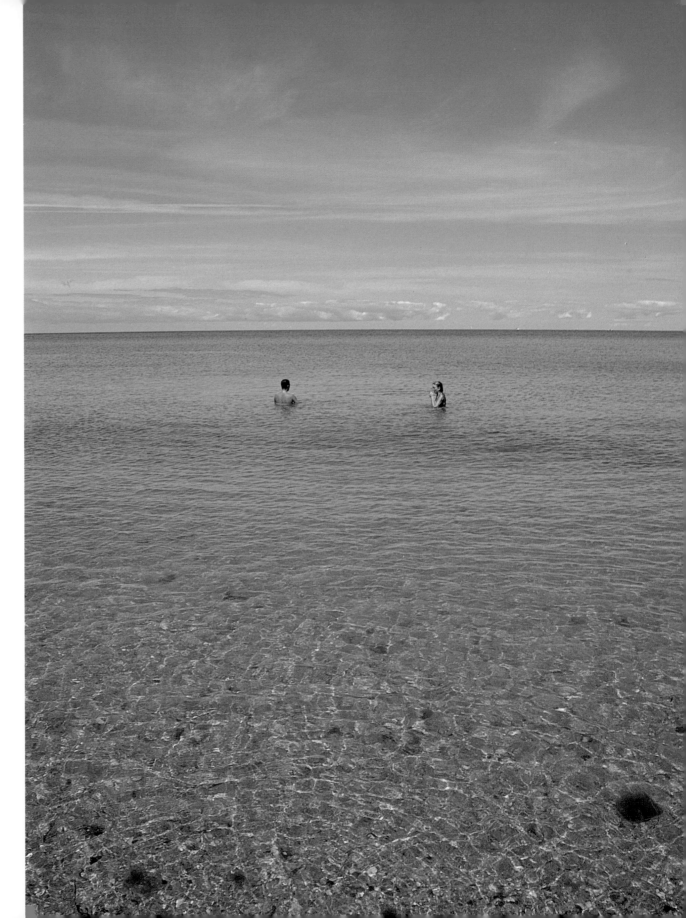

Jetties Beach

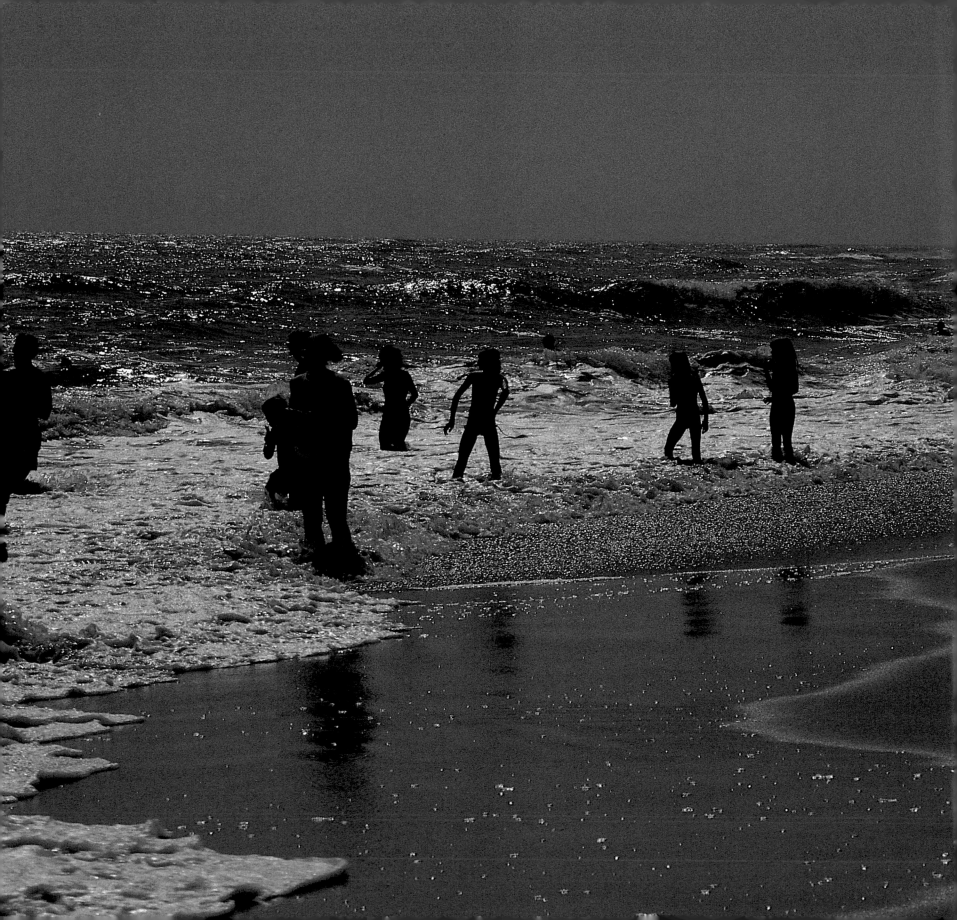

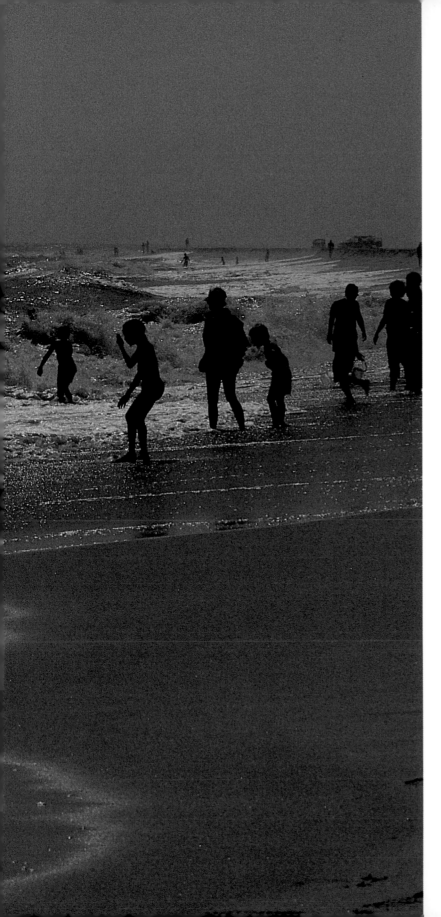

Surfside

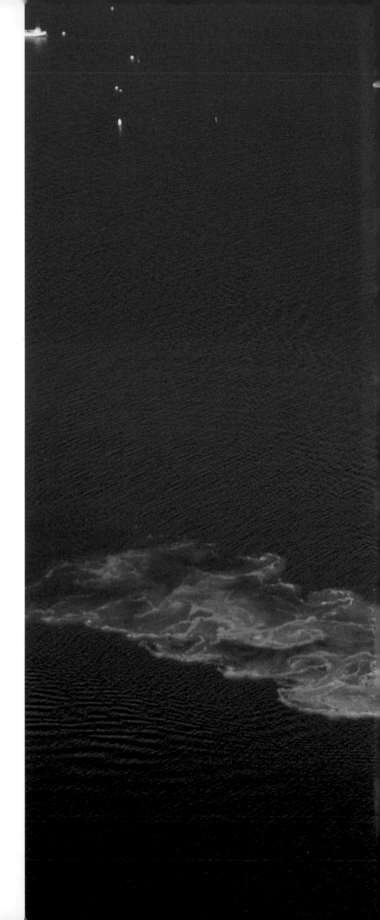

I think Nantucket is a real gift.

There are changes in it,

and those changes are inevitable,

but the essence of the place is still the same.

Everyone should have a Nantucket.

MARY BETH SPLAINE
Counselor

Steamship *Eagle*
rounding Brant Point

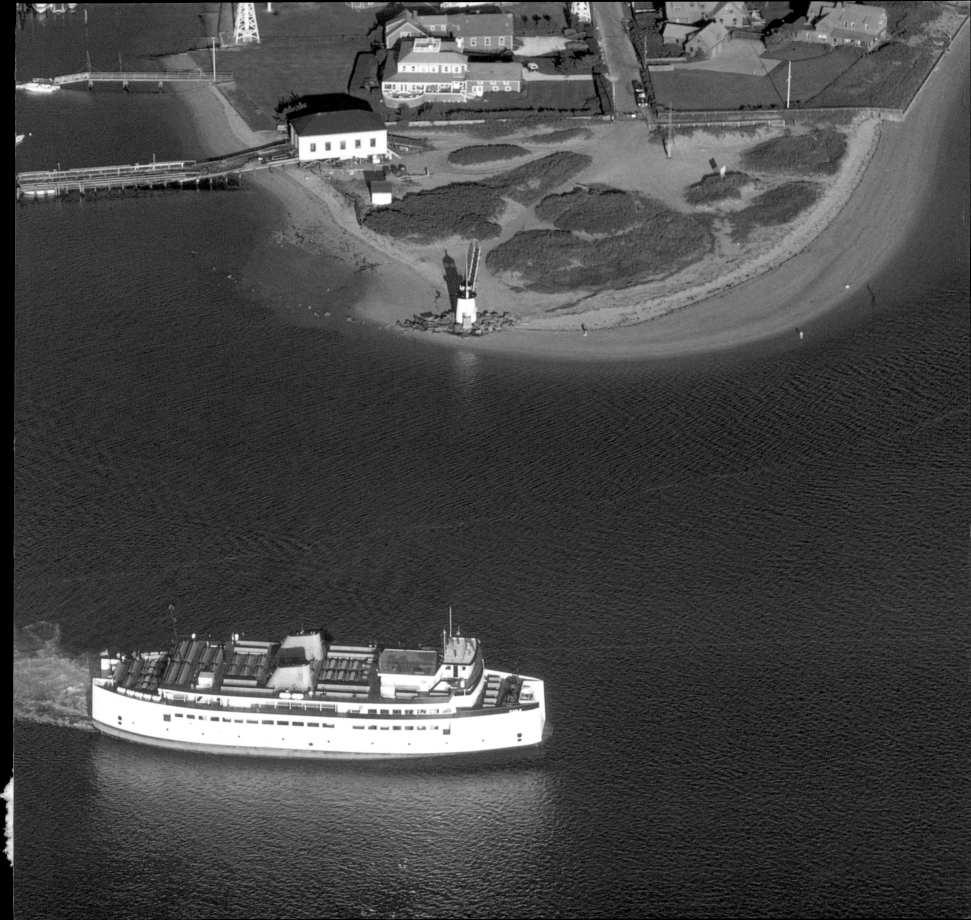